**THE OIL PAINTER'S
GUIDE TO PAINTING**

WATER

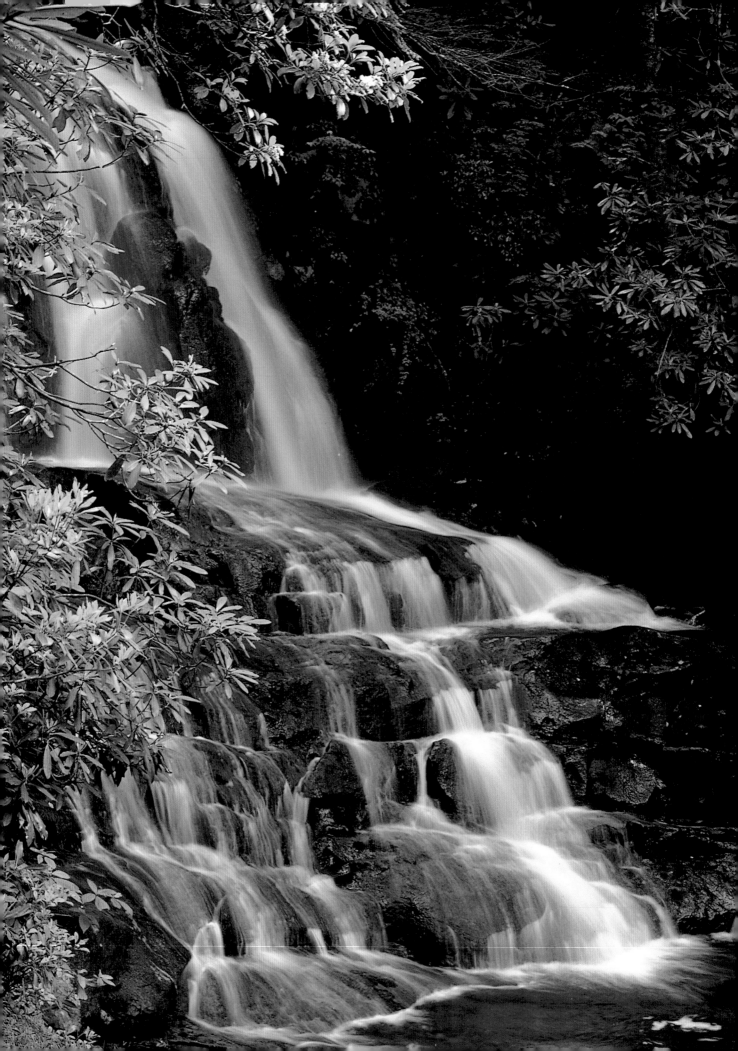

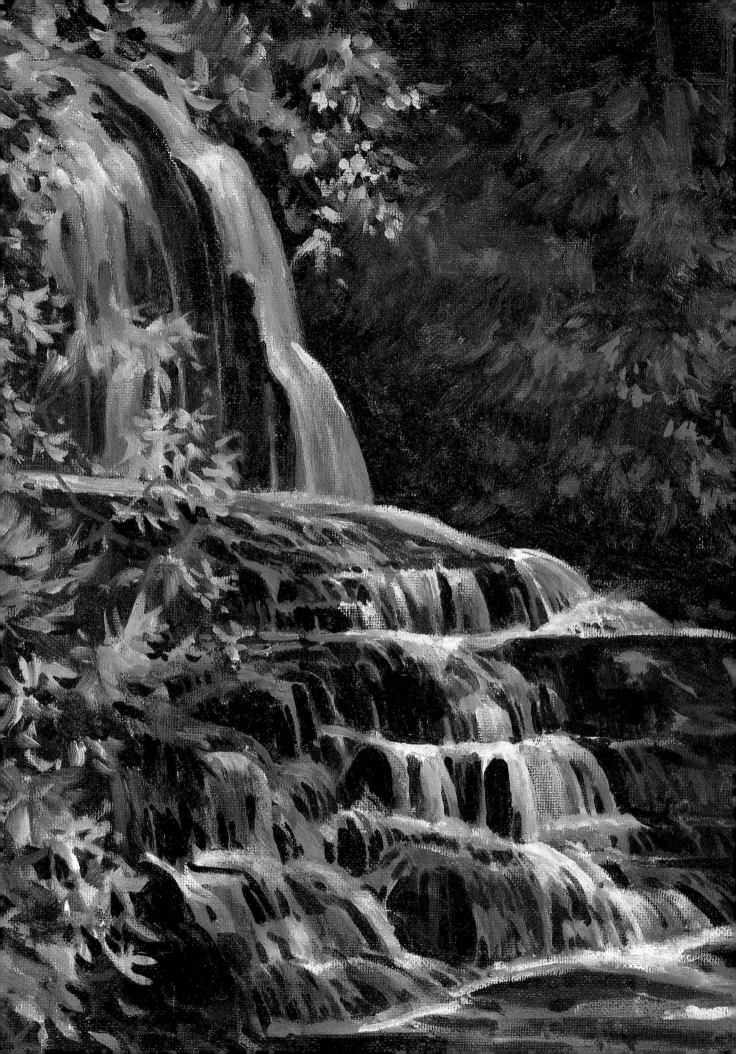

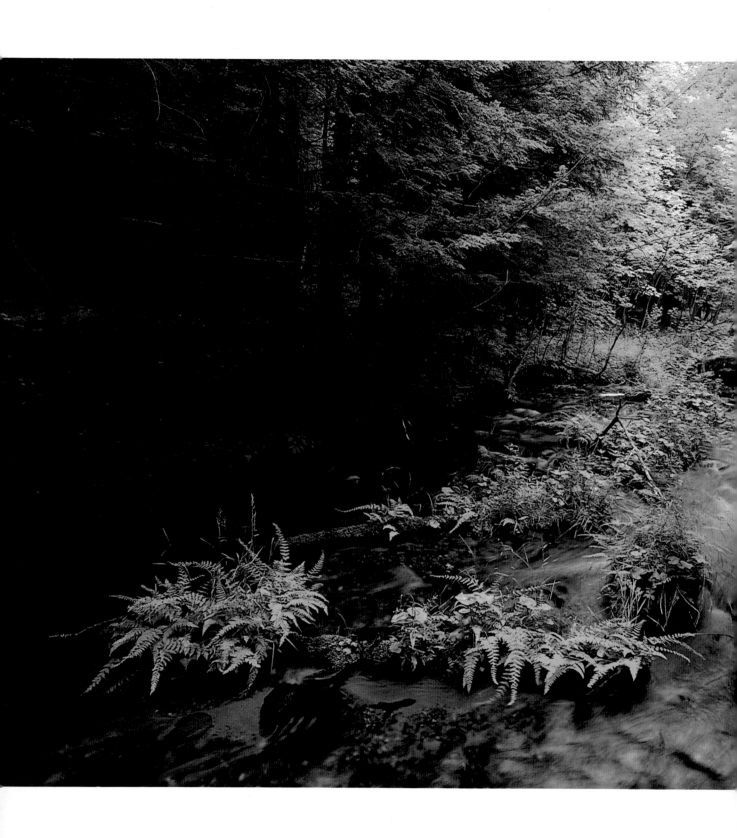

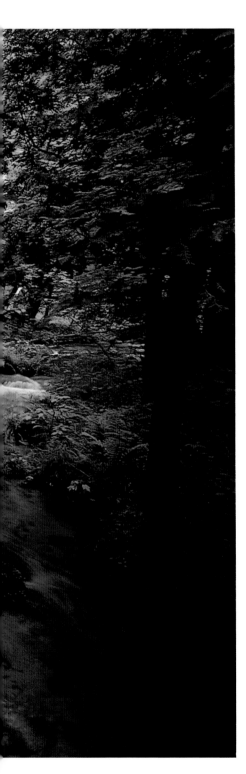

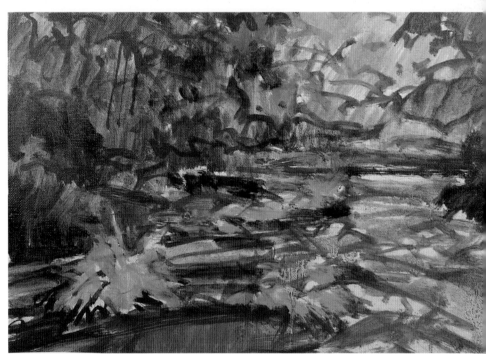
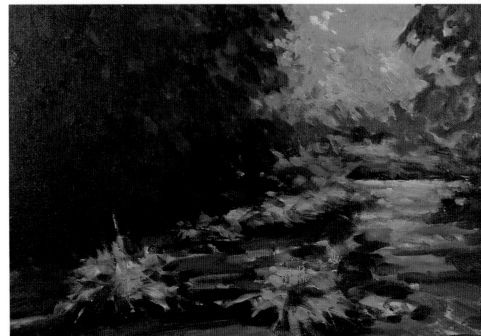

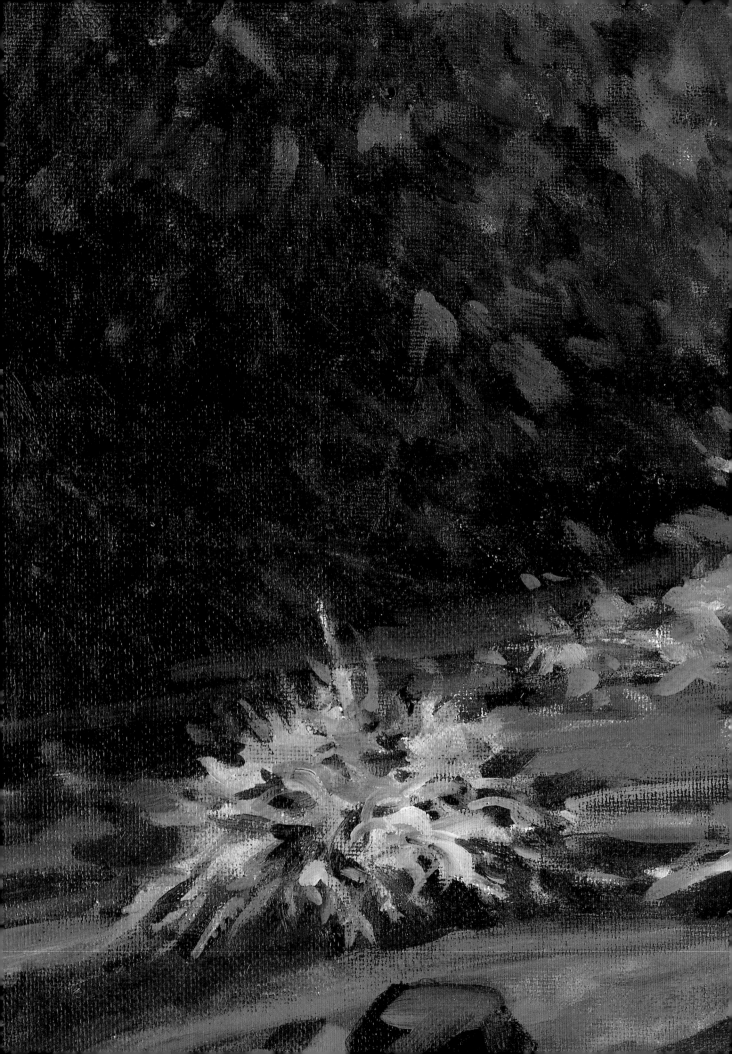

THE OIL PAINTER'S GUIDE TO PAINTING
WATER

PAINTINGS BY S. ALLYN SCHAEFFER
Photographs by John Shaw

Watson-Guptill Publications/New York

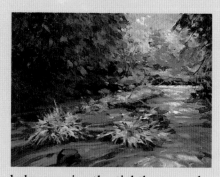

PAGES 2–3

Deep within a forest, frothy water cascades over cool dark rocks.

Filled with detail and strong contrasts, this scene might easily become confusing and overly dramatic. To control the subject, simplify the dark foliage in the distance. Before you begin to paint, analyze the waterfall carefully, noting how it breaks into vertical and horizontal planes.

Now execute a complete, detailed drawing that will act as a guide when you begin to lay in color. Using thinned color and working from dark to light, establish the colors and values that make up the scene. When the major elements are down, switch to opaque pigment and start to build up the dark green backdrop, then lay in the rocks with strokes of burnt umber.

As soon as you have developed the rocks, turn to the patterns formed by the cascading water. Keep two things in mind. First, if you add too many crisp, bright whites, the sun-struck foliage in the foreground will lose its power.

Second, don't copy what you see too slavishly—try instead to capture the feel of falling water.

Finally, render the bright green leaves that fill the foreground with Thalo green and Thalo yellow-green, warmed in places with dashes of yellow ocher. Use short, choppy strokes to further separate these bright leaves from the greenery in the background.

PAGES 4–7

In midsummer, a stream rushes through a forest, standing out against a sun-struck glade.

The trees that lie on either side of the stream are closely packed together, forming an unrelieved curtain of dark green. To give your painting focus, concentrate on the light grasses in the foreground and on the sunny glade in the distance and simplify the dark green foliage.

Place the main shapes on your canvas in a simple charcoal drawing, then reinforce your drawing with thinned color. Use varying shades of light and dark green to

help organize the tightly massed foliage and quickly establish the colors and values of the scene. Work from dark to light, leaving some white canvas in the lightest areas of the stream.

The overall composition established with thinned color, turn to thicker opaque pigment. First repaint the dark foliage with Thalo green and burnt sienna. Vary these darks with small brushstrokes made up of different mixtures of Thalo green and alizarin crimson or Thalo green and cadmium orange. Next define the patterns of the stream, keeping the distant, water lightest.

As you begin to develop the foreground grasses, work back and forth between the greens and the darks that run through the stream. Most important, let your brushstrokes follow the movement of the water.

In the finished painting, the brilliant spring greens of the distant glade and the vegetation in the foreground stand out sharply against the water and the trees, and the water ties the two light areas together visually.

First published 1986 in New York by Watson-Guptill Publications, a division of Billboard Publications, Inc., 1515 Broadway, New York, N.Y. 10036

Library of Congress Cataloging in Publication Data
Schaeffer, S. Allyn, 1935–
 The oil painter's guide to painting water.
 Includes index.
 1. Landscape painting—Technique. 2. Water in art.
I. Shaw, John, 1944– II. Title.
ND1342.S32 1986 751.45'436 85-26298
ISBN 0-8230-3268-X

Distributed in the United Kingdom by Phaidon Press Ltd., Littlegate House, St. Ebbe's St., Oxford

Manufactured in Japan

1 2 3 4 5 6 7 8 9/90 89 88 87 86

Contents

Introduction

Baffling, complex, and forever fascinating, water has captured the imagination of artists for centuries. Often considered the province of those lucky enough to live near the sea or large lakes and rivers, water is actually close at hand for every artist—even those who live in land-locked areas, far from majestic rivers or rushing waterfalls.

A single puddle of rain water can hold a universe of visual information, and the changing moods of a little stream or pond can captivate an artist for years. Water changes as the wind stirs over its surface and as the sun traces its path across the sky. One moment placid and brilliant blue, the next moment it may be tumultuous and a steely gray. The same river that flows quietly on its way through spring, summer, and fall may be transformed, too, as the temperature falls and its water turns to ice.

Master the art of painting water and inject your landscape paintings with new vigor. Learn how to capture the true color of water, how to render a sweeping wave, and how to depict a translucent waterfall. Discover how fog and mist transform a landscape and the most effective ways of painting the clouds and sky that lie reflected in a river or lake. In the lessons that follow, you'll learn how to master all this and more.

Most exciting, this book goes beyond exploring water in the conventional sense. As you move through the lessons, you'll discover the wealth of material that lies hidden in nature—the abstract beauty of water rippling over sand, the geometrical precision of a snowflake, and even the elegance of a single icicle.

As you begin to work through the lessons, you'll become acquainted with the breathtaking world of water—a land rich in possibilities for everyone who loves to paint.

WHO THIS BOOK IS FOR

If you've worked with oils before, you'll immediately feel at home with this book. It's geared toward the intermediate artist—one who has mastered the basics of oil painting.

But if you are starting out, don't despair. Even if you are just becoming interested in painting, you'll find that this book can make it much easier for you to find your own particular style.

Before you begin to work through the lessons, explore the basics of working in oil. Learn how to prepare a wash with turpentine, which painting medium you prefer, the brushes that you feel most comfortable with, and the supports that work best for you. Then start to paint.

Don't be overly ambitious at first. Start with simple subjects. As you develop confidence, you'll discover how to approach whatever it is that you see.

HOW THIS BOOK IS ORGANIZED

This guide contains fifty lessons, each dealing with a problem you are likely to encounter when you start to render water in oil. Each lesson begins with the problem you will confront, then goes on to discuss how to solve it. When several approaches make sense, you'll learn why one is preferred.

The core of this book consists of explaining how each painting is executed. From start to finish, you can follow how the artist painted the subject. In many lessons, step-by-step photographs reveal how the painting actually evolved.

Sprinkled throughout the book you'll find assignments designed to help you apply what you have learned to your own paintings. You can start wherever you like— at lesson one or at lesson 45. To get the most help from the assignments, though, it helps to read through the corresponding lessons first.

THE PHOTOGRAPHS

At the beginning of every lesson you'll find the photograph that the artist worked from as he painted. By studying the photograph, then the finished painting, you'll learn how the artist interpreted his subject matter—an advantage that few books provide.

More than that, these superb photographs can help you learn new ways of composing your paintings and new subject matter, too.

As you turn to each new lesson, spend a few minutes studying the photograph. Try to figure out what makes each shot work. How did the photographer frame the composition? Did specific lighting conditions enhance the subject? What angle did the photographer shoot from? Did he place the horizon low or high in the picture plane?

When you go outside scouting new subjects, put what you've learned into action as you block out your compositions.

THE ROLE DRAWING PLAYS IN PAINTING

Before you begin to paint, it pays to render the scene on canvas with charcoal. A preliminary drawing acts as a guide; once it's down, you are less likely to lose your way as you paint.

You needn't be a master draftsman to execute a simple sketch, but you'll find it easier if you are

comfortable with the basics of drawing. Get in the habit of carrying a sketch pad with you and use it whenever you encounter an appealing subject. Work all over the sheet of paper, rapidly laying in the major lines that make up the composition. In your drawing, try to express whatever it is that gives your subject its particular appeal.

When you start work on an oil painting, first sketch the scene with soft vine charcoal—it's incredibly flexible and gives you great freedom. If you're unhappy with what you've put down, you can brush it away with a tissue and start again.

For complicated closeups you may prefer to use a charcoal pencil. It provides a firmer, stronger line that's less likely to get lost as you paint. But if your drawing disappears as you build up the canvas, don't despair: As soon as the paint dries you can go back and sketch the scene again, right on top of the pigment.

In some painting situations you may want to stain your canvas with an overall wash of color before you begin to paint. When you choose this approach, and you are working with a dark hue, try sketching the scene with a white charcoal pencil.

A final note: In most of the lessons, you'll find that the preliminary drawing is reinforced with thinned color. Don't think of this as a mechanical step, one where you simply trace the lines that you've laid down in charcoal. In fact, it's a vital part of the painting process.

As you reinforce the initial sketch with color, what you are actually doing is setting up the color mood of the entire painting. For simple compositions, one neutral hue may be sufficient. For more complex subjects, search for the hue that dominates each area, then use it to back up your drawing. Building up local color

right away will make the painting process much easier. When you begin to lay in washes of color, you'll have a logical starting point, one that makes it easier to face that agonizing moment when brush first meets canvas.

SELECTING COLORS
The paintings in this book were all executed using nineteen colors. In most paintings, though, only five or six hues are actually employed. Here's the basic palette that you'll find:
White
Cadmium yellow light
Cadmium yellow deep
Yellow ocher
Raw sienna
Cadmium orange
Cadmium red light
Alizarin crimson
Burnt sienna
Burnt umber
Mars violet
Raw umber
Cerulean blue
Cobalt blue
Thalo blue
Permanent green light
Thalo green
Thalo yellow-green
Ivory black

Try setting your palette up using these colors, placing them from left to right in the order given here.

If you've been working with oil for a few years, you probably know which colors you prefer. Even if they solve most of the situations you encounter, don't limit yourself to them. Experiment! Introducing one or two new hues to your palette can be the key to injecting your paintings with vigor.

If one or more of the colors used in this book are new to you, give them a try. Feel free, too, to go beyond the palette used here. A particular blue not mentioned in this book may open new worlds for you, so keep an open eye when it comes to color.

CHOOSING THE RIGHT BRUSHES
Most of the brushes you'll need are bristles. They come in three basic shapes: flats, filberts (oval-shaped), and rounds (with a pointed tip). Fairly stiff, these brushes are ideal for laying in broad expanses of color and for executing loose, dynamic strokes. Experiment with these brushes and learn the strokes that each one produces.

When you turn to detailed work, you'll probably want a sable brush. Soft, pliable—and expensive—sables are great when you are refining an area that you've already laid in. Take good care of all of your brushes and you'll find that they last you for years.

MISCELLANEOUS MATERIALS
Working outdoors, you'll need a good, sturdy easel, and with a portable one, you'll find it easier to paint spontaneously. Carrying the easel and the rest of your gear when you go outdoors can prove a challenge. Search through art supply stores—and hardware stores—till you find a case ample enough to carry everything you need in the field.

Paints and brushes do not a painter make. You'll also need turpentine or mineral spirits for thinning pigment and cleaning up, plus at least one painting medium. Painting and palette knives are also important, as are rags and paper towels.

If you choose to prepare your own painting medium, try using four or five parts of turpentine to one part varnish and one part stand oil. This mixture is cheaper than prepared mediums, and works just as well.

Occasionally you may want to retard drying time, and prepared mediums that do just this are readily available. You can also find those that make paint dry more rapidly.

SELECTING THE RIGHT SUPPORT

Stretching canvas was once a necessity, but now it's an option—great if you have the time and if bulk doesn't matter. It leaves you free to choose the texture of the fabric you'll work on and you can prime the support just the way you want it to be primed.

For many, though, prepared canvases and canvas boards are a delight. They are ready when you are, and take up very little space.

What's wrong with them? For one thing, they come in a limited number of sizes, and if you are working with an unconventional format, you may find that these standard sizes get in your way.

Other options are available, too. When you move in on a close-up, or start to depict a detailed subject, try working on Masonite. Its smooth surface is ideal when the weave of canvas might disrupt an intricate subject.

Finally, don't forget paper. Sized with an acrylic mat medium or white shellac, watercolor paper is great when your subject is made up of rough elements that mimic the feel of the paper—cresting waves, for example.

CHOOSING A SUBJECT

Water presents the landscape artist with countless subjects, ranging from dramatic stormy lakes to still, quiet tide pools. Each subject has its own particular charm and challenges.

When you begin working with water, steer clear of complex, dramatic scenes. Wonderful to look at, they can be extraordinarily difficult—and discouraging—to paint. Start instead with simple subjects. Try capturing a quiet stream, or a calm lake shore. Once you have mastered it, move on to a subject that is slightly more difficult to render. Working slowly, gradually accumulating skills, you'll eventually find yourself well equipped to tackle even the most challenging waterfall or wave-washed shore.

DEVELOPING YOUR OWN STYLE

There's no one way to paint a subject—approaches are as varied as artists are themselves. Where one painter may be attracted to a vast, panoramic view of a rushing river, another artist, standing in the same spot, might choose to concentrate on just a few inches of the riverbed. And even if they should decide to focus on the same basic composition, their paintings might still easily be as different as night and day.

Discover the approaches that best suit your view of the world. The photographs in this book provide you with a starting point, showing you how one painter successfully conquered the problems he encountered when he set out to execute a painting. As you explore his solutions, you'll probably think of different ways to master different situations. If you approach each lesson with an open, curious mind, you're bound to. When you turn to a new lesson, spend a few minutes studying the photograph before you begin to read the text. What will be hard for you to capture? The color of the water? The way the light plays upon it? Balancing a strong blue against brilliant greens? Next, think through your solution to the problems you've discovered.

Once you have evaluated a composition, turn to the text and find out how the painting was done. You may want to follow the steps that we provide, but if the approach you've figured out makes more sense to you, give it a try. Rapidly you'll discover when to trust your instincts and—most important—how to capture your own particular vision of water and the myriad forms it takes.

Painting Water in Winter

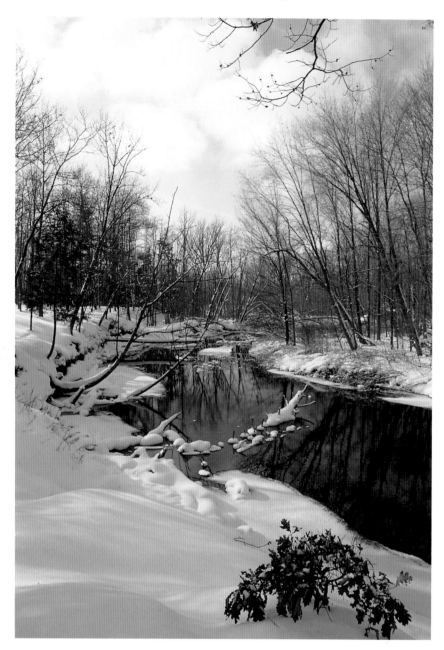

PROBLEM
Set against the crisp white snow, the stream seems even darker than it actually is. Unless the water is handled carefully, it will look flat and dull.

SOLUTION
To make the stream lively and interesting, exaggerate the reflections that animate it and simplify the patterns of the surrounding snow and trees.

STEP ONE
Sketch the scene with soft vine charcoal, then go over your drawing with thinned color. At this point, don't clutter up your canvas with too much detail. Instead, concentrate on large shapes. Once your drawing is reinforced, establish the dark stream with thinned color to set the scene's overall mood. Use a blend of Thalo blue and alizarin crimson, with just a bit of white.

In midwinter, a stream courses through a snow-covered landscape, reflecting the myriad trees that grow near the water.

STEP TWO

Working with thinned color, start to block out large masses of color—the blue of the sky, the cool mass of trees in the distance, and the sloping, ice-covered ground. Keep your treatment simple; later on you can add more complex shapes. For the sky, use cerulean blue, white, and Thalo green. Render the trees in the distance with Mars violet. Finally, for the snowy ground, lay down cerulean blue and white, mixed with just a touch of black.

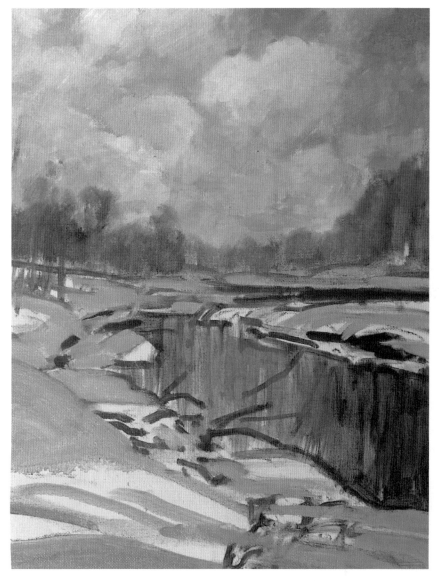

STEP THREE

The framework of your painting established, build on it with thicker opaque pigment. First paint the sky, working right over the spindly treetops; you will add them later. Here the shadowy portions of the clouds are rendered with raw umber and white, the light areas with yellow ocher and white, and the sky itself with cerulean blue, Thalo green, and white.

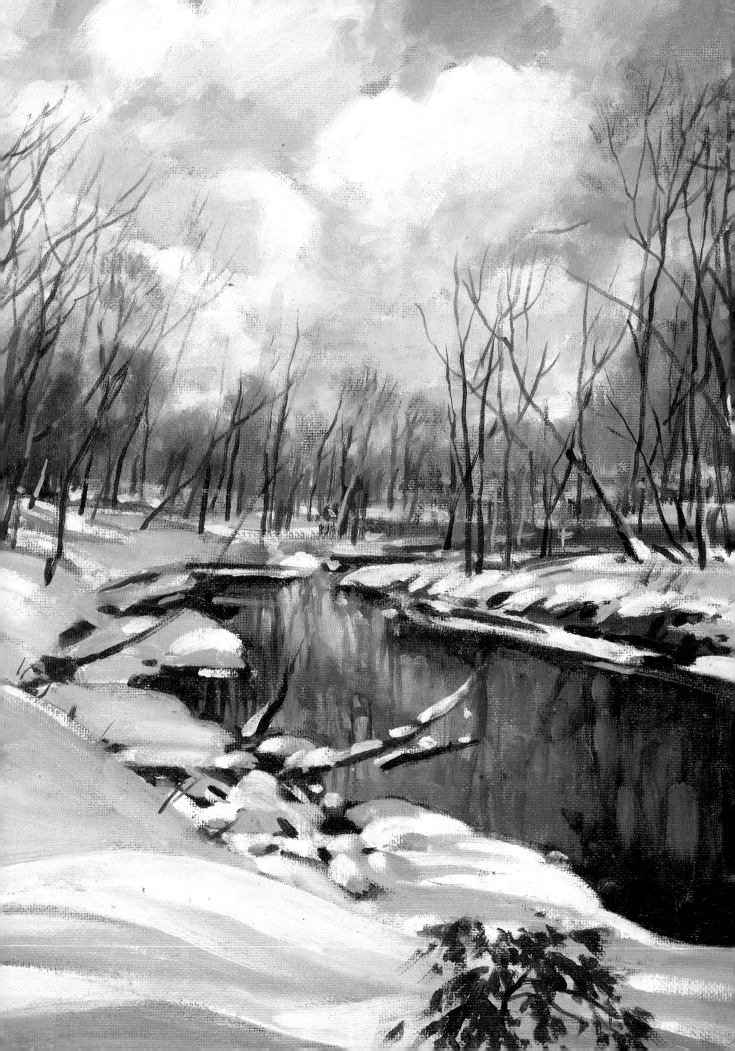

FINISHED PAINTING

To complete your painting, turn to the stream and the snow. Suggest the maze of reflections that lie in the water with a wet-in-wet approach and strong vertical strokes. In the immediate foreground, add burnt sienna to the Thalo blue to achieve a dark, dense hue.

The stream completed, evaluate the snow-filled foreground. You may want to soften the shadows with additional strokes of pale blue paint tinged with a little cadmium red. Next, strike in all of the dark trees using a small pointed brush and color thinned with a painting medium. The medium will keep the pigment fluid, allowing you to coax the color over the canvas.

As a final touch, loosely lay in the tangle of dead leaves in the immediate foreground.

DETAIL

Rendered with short vertical strokes, the water is filled with all the reflections that spill across it. Because the shadows that lie on the snow are painted primarily with blue, the snow and the water work together harmoniously.

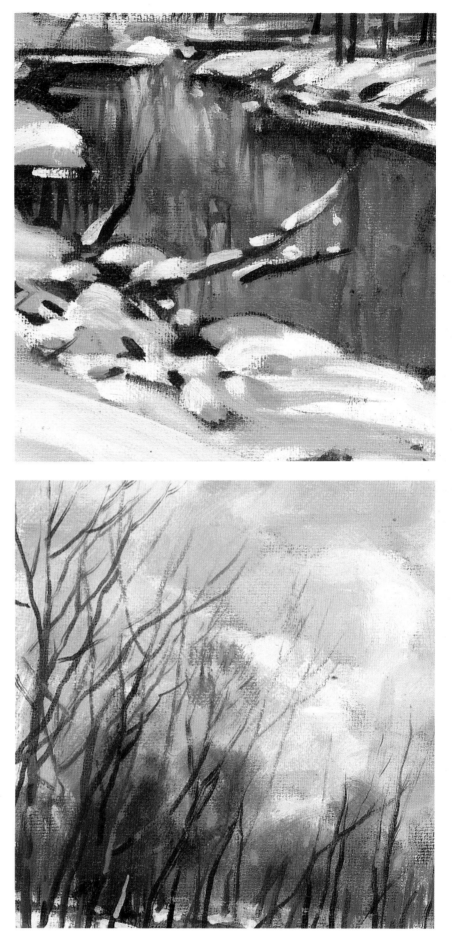

DETAIL

The trees are built up in two stages. First, a cool violet undercoating is scrubbed onto the surface to suggest the trees in the distance. Later, individual trees are rendered with a small pointed brush and pigment that has been thinned with painting medium.

Deciphering Complex Patterns

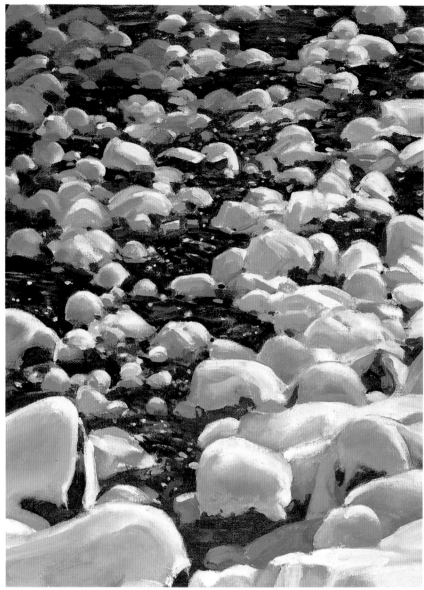

PROBLEM

All of the rocks are about the same size and shape and the water is dark and flat. Unless you compose your painting carefully it will be static and repetitious.

SOLUTION

Organize the rocks into groups, especially those in the foreground. When it comes time to paint the water, emphasize the subtle highlights that flicker over it.

☐ Sketch the scene with charcoal, paying as much attention to the spaces between the rocks as to the rocks themselves. Now redraw the composition with a brush dipped into thinned color.

Continue working with thinned color as you begin to establish the overall pattern of lights and darks. First, lay in the dark water and the shadows that fall on the snow-covered rocks. For the time being, let the white canvas represent the snow.

Switch to heavier paint and rework the water with a dark rich hue mixed from ultramarine blue, alizarin crimson, and Thalo green. In places, introduce dabs of burnt umber and burnt sienna. Use short, choppy strokes to suggest the movement of the water. As you render the rocks, use broader, smoother brushstrokes. Here the snow is painted with cobalt blue, white, and a small touch of cadmium red.

Spend a few minutes evaluating your painting, then fine tune it. Make sure that edges are sharp and clean where snow and rock meet water and that the snow looks soft. As a final step, add dashes of white to the dark water to suggest the play of light.

Thick white snow clings to the rocks lining a stream as dark water trickles around them.

18

Achieving a Flat, Decorative Effect

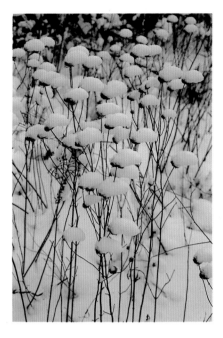

PROBLEM

This is a highly unusual subject. It is flat, monochromatic, and repetitious—yet these very qualities inject it with a handsome, abstract beauty. Capturing this flat, decorative look is the challenge here.

SOLUTION

Before you start to paint, analyze the composition, looking for a strong design element to pull it together. Here it lies in the flowers, which, overall, form an inverted triangle.

☐ When you begin work on a complicated subject filled with detail, execute a careful drawing with a charcoal pencil, then spray the drawing with a fixative so you won't lose it as you work. Now reinforce your work with thinned color.

Because the shifts in color and value in this subject are subtle, build up your painting slowly using glazes—pigment thinned with a painting medium. Start with the darkest passages—the stems and shadows—then move on to the lighter areas of the composition. As you work, gradually start to

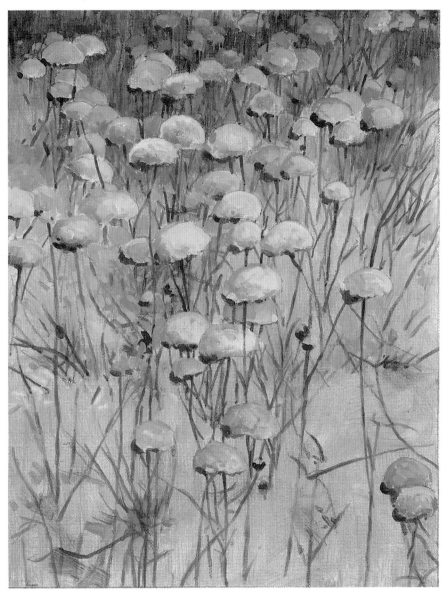

refine edges and strengthen your darks and lights.

Here the hue that dominates the composition is made up of white and black mixed together with cobalt blue. In some areas, burnt and raw umber take the place of the blue; in others, touches of Mars violet are introduced.

When your painting is almost finished, feel free to use heavy touches of opaque color to reinforce weak areas. Here opaque paint is applied to the tops of the blossoms to accentuate their crisp, bright highlights.

In midwinter, snow lies on top of dead blossoms, while their stems etch a tangled pattern against the snowy ground.

Subduing Bright Whites

PROBLEM

Except for the snow, everything in this scene is so dark and somber that you may be tempted to make the whites too bright. If you do, you'll lose the haunting, secluded feel that permeates the composition.

SOLUTION

Tinge your whites with cool blues and gray. You'll discover that treated this way, they still stand out strongly against the dark trees and water, but they aren't too sharp and disruptive.

☐ Execute a loose charcoal drawing to establish the rocks in the foreground and the way the stream moves backward, then reinforce the sketch with thinned color. Continue working with thinned color as you brush in the dark trees in the background, then the water. At this stage, keep the trees as simplified as possible. Here they are made up of Thalo green and burnt sienna.

The stream is laid in with Thalo green, alizarin crimson, and white. Once you have established the overall configuration of the greenery, build it up with thicker pigment, then go back and add detail with a fine brush. Next, develop the stream with opaque pigment.

The darks down, get started on the snow-covered rocks. If the stream and the trees are dark and rich enough, it will be easy for you to gauge the value of the snow.

Working with opaque pigment, begin to lay in the snowy ground on the left and the rocks that reach out of the stream. Your basic mixture will be black and white, with touches of cobalt and cerulean blue to temper the gray.

All that remains to be done now is the immediate foreground. First paint the tall tree on the right, then, working with a small brush, articulate the snow-covered branches that radiate outward. As a final touch, add the delicate branches in the lower right corner using a drybrush technique.

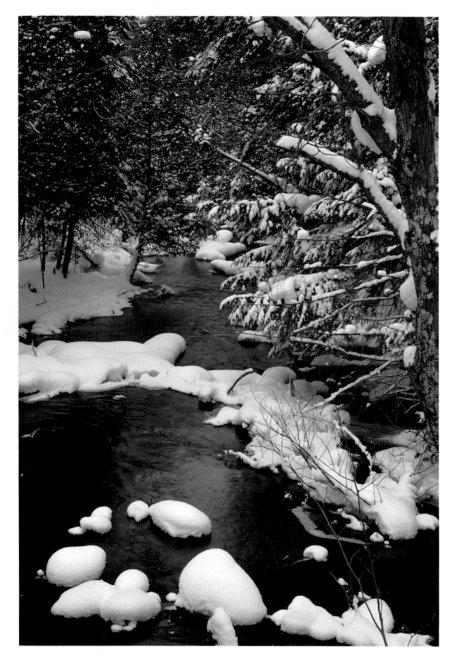

A cool, dark stream rushes through a snowy forest.

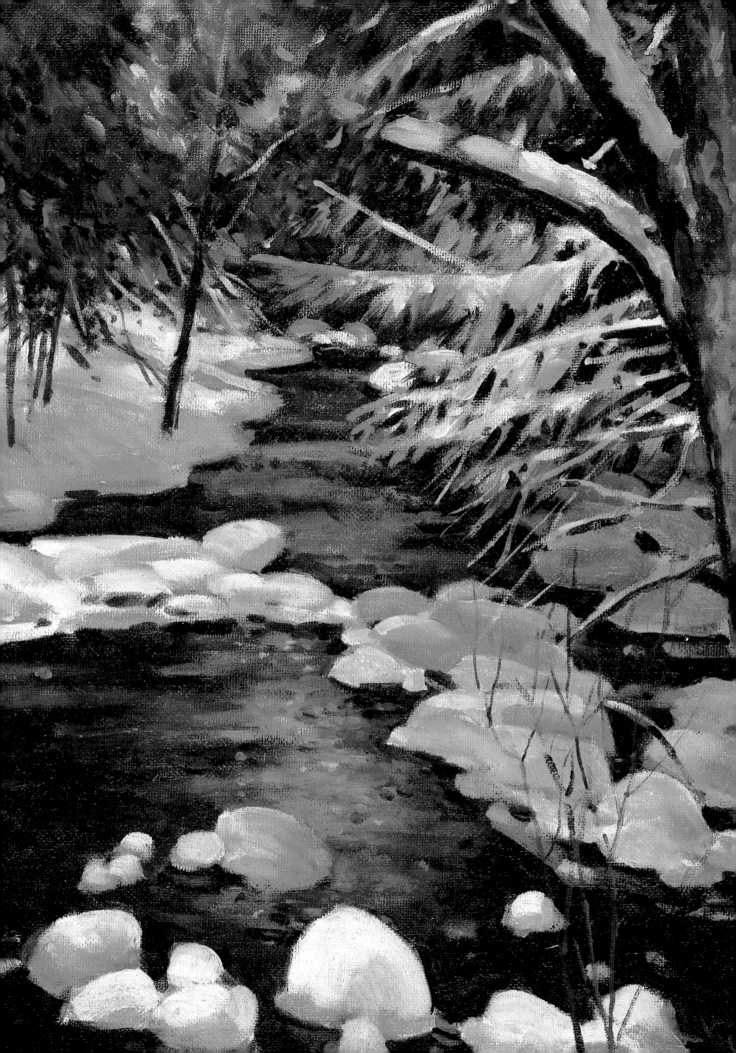

Rendering Reflections at Sunset

PROBLEM

At first glance, this scene seems lighter than it actually is. If your values are too light, you won't be able to capture the power of the reflections or the effect created by the setting sun.

SOLUTION

Exaggerate what you see and render the sky and lake with strong, deep color.

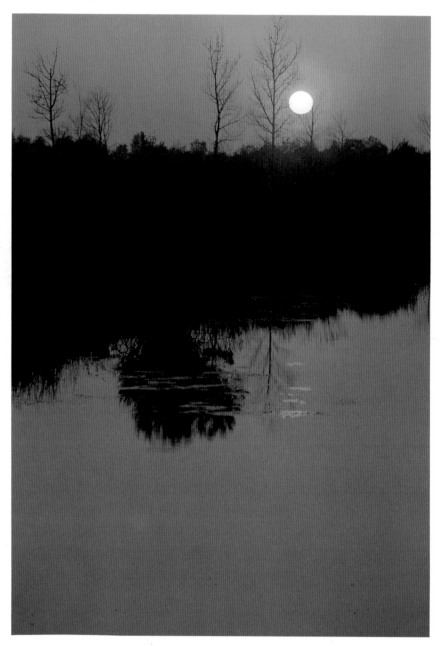

As the sun sinks toward the horizon, filling the sky with a rosy glow, reflections spill across a still lake.

☐ Because the composition is simple, there's no need to sketch the scene with charcoal before you begin to paint. Instead, lay down the major lines of the composition—the land mass and reflections—with a small brush dipped into thinned alizarin crimson. For now, don't worry about the tall, bare trees.

Right from the start work with opaque pigment. First lay in the dark land mass and its reflection with a rich mixture of alizarin crimson and Thalo green. To separate land from water, sweep dark cobalt blue across the edge where they meet, then turn to the sky and water.

The rosy glow that pervades the sky is echoed in the water. Since the two areas are the same color, paint them at the same time using strong, dark hues. Here they are rendered with alizarin crimson, cadmium red, and white, with small touches of cobalt blue added in places. Don't be afraid to exaggerate the color; it has to be really dark if the sun is going to stand out clearly.

As you paint the sky, use smooth, fluid strokes. Work from the edges of your canvas in toward the sun, and make your color lighter and lighter as you near it. For the water, lay in shorter, choppier strokes to suggest the ripples that run across it. The touches of cobalt blue that are added to the foreground pull it out toward the viewer and keep the painting from becoming flat.

Now paint the sun, using white and cadmium yellow. Don't mix the two colors together; instead, lay them in separately with heavy strokes. Finally, with a small, pointed brush dipped into alizarin crimson and Thalo green, render the individual trees that stand out against the sky and their reflections in the water.

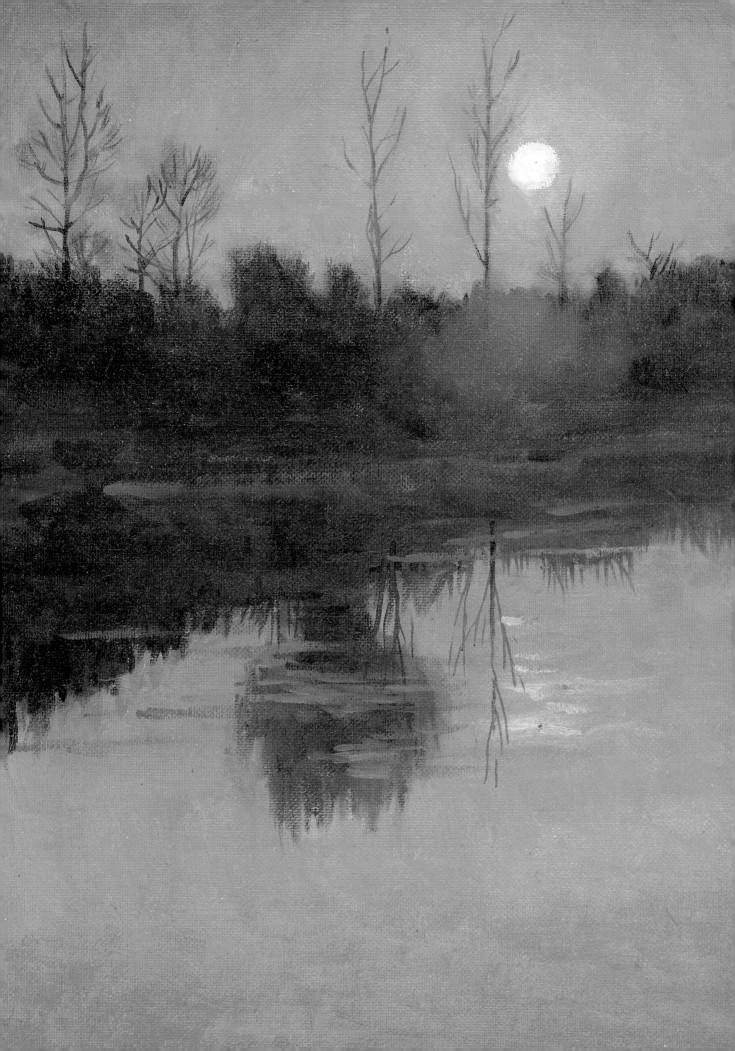

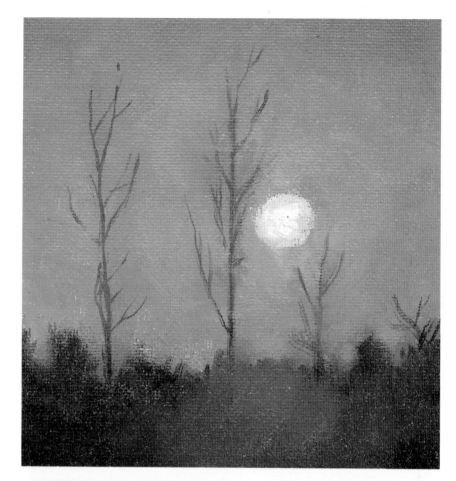

DETAIL
To paint the sun, first lay in pure white, then go back and add cadmium yellow. By mixing the colors on the canvas and not on the palette you'll increase the strength and brilliance of the sun.

DETAIL
Slashes of rose-colored pigment run across the reflections, suggesting the movement of the water. More than just that, they make the reflections seem lighter and more natural.

Working with Fading Light

PROBLEM

Two distinct situations are at play here—the lingering light that fills the sky and lies reflected in the water, and the cool, shadowy feel of the trees and land. Both have to be captured.

SOLUTION

Pack the sky and water with all the color and light that you see, using warm hues. Render the land and trees with darker, cooler tones.

□ Quickly sketch in the scene with vine charcoal, then go over the lines of your drawing with thinned color.

Continue working with thinned color as you begin to lay in the dark trees and their reflections. Work quickly, with dark cobalt blue, and keep the trees simple; if they become too complex, they'll steal attention away from the sky and water. Note, too, that the reflected trees are darker than the trees themselves. Now quickly brush in the water with thinned cerulean blue.

On top of your thin underpainting, introduce thicker pigment. First build up the trees with short, broken strokes of cobalt blue, yellow ocher, alizarin crimson, Mars violet, and raw sienna. Make sure your values are really dark so that the light in the sky and water stands out clearly.

Next, begin to paint the sky. Here it's made up of Thalo green, white, and cadmium yellow.

Now the fun starts—painting the water. Because you want to pack it with as much color as possible, mix small batches of color repeatedly instead of mixing it all at once. You'll find that working this way, you achieve a much richer and more lively effect. Here are the colors you'll need: cerulean blue, Thalo green, cadmium orange, yellow ocher, cadmium yellow, alizarin crimson, cadmium red, and white. Note that yellows dominate toward the rear of the painting, while blues make up most of the foreground.

The sky, land, and water down, turn to the foreground and paint the tree on the right. Make it warmer and brighter than the trees in the background, but don't let it become too sun-struck.

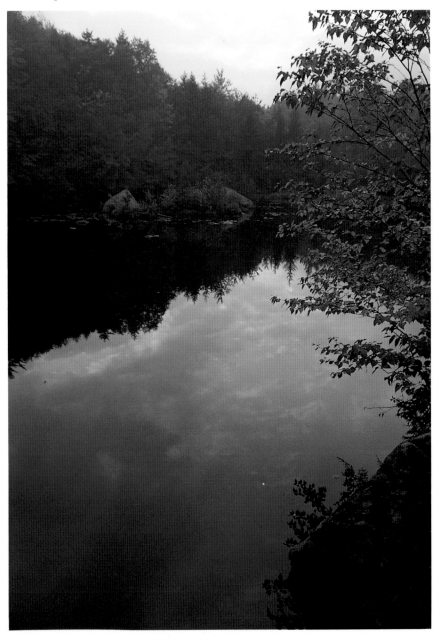

Moments after the sun has set, its warmth still colors the sky and water while trees and land are cast in shadow.

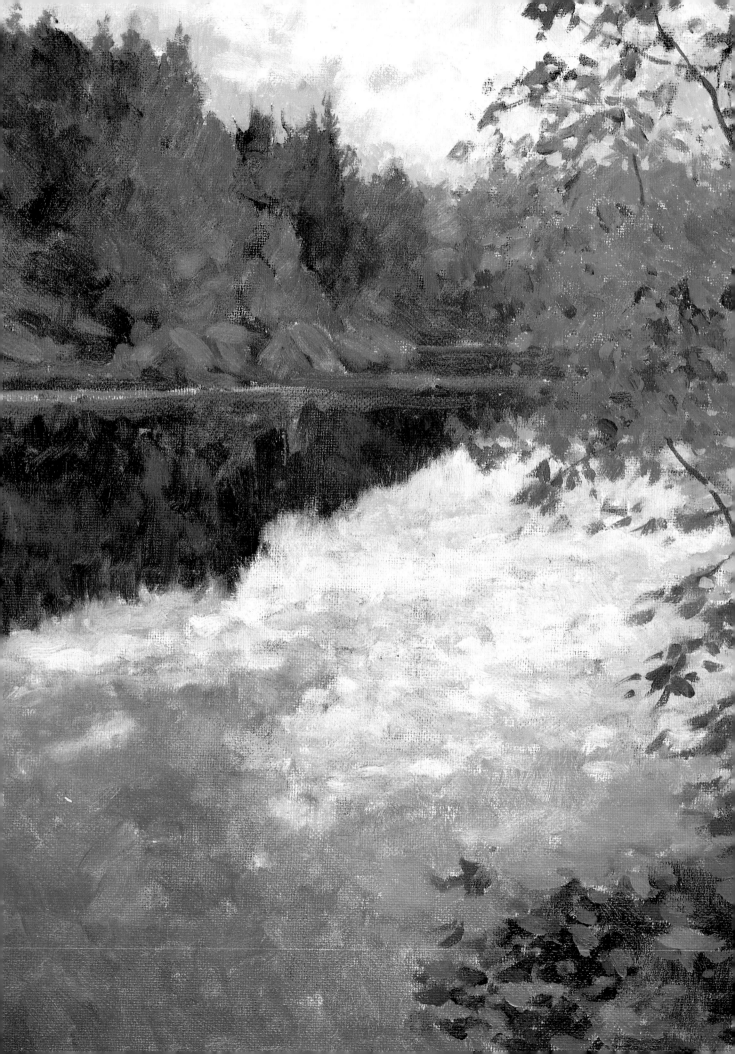

DETAIL

Beautiful color fills the water. Almost every stroke is blended individually, resulting in interesting variations in hue. Eight tones are employed: cerulean blue, Thalo green, cadmium orange, yellow ocher, cadmium yellow, alizarin crimson, cadmium red, and white.

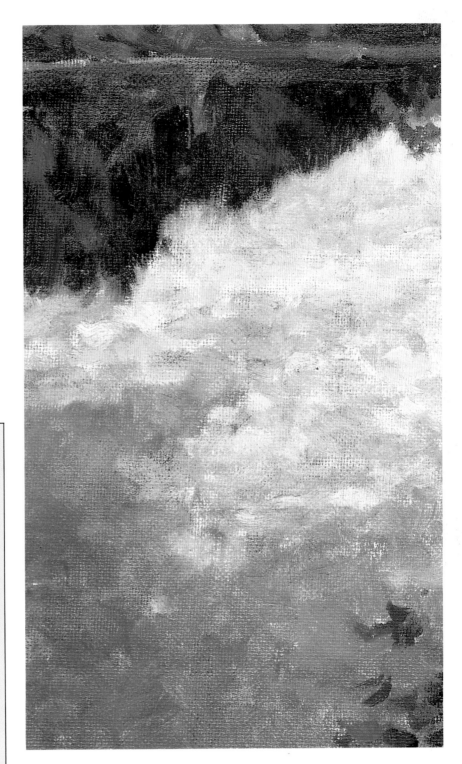

ASSIGNMENT

Strong drawings help make strong paintings—they add structure to your compositions. If you are not in the habit of executing preliminary sketches, experiment with soft vine charcoal and discover what it can do for you. No other drawing medium can be changed as quickly; one sweep of a rag and the charcoal's gone. When you are happy with your sketch, you can dust off any loose charcoal; enough of the drawing will remain to guide you as you reinforce its lines with thinned color. The freedom this gives you is immense—you can make as many adjustments as you like without dirtying up the canvas.

When the color theme of a painting isn't likely to cause you any trouble, use a dark neutral hue to reinforce the sketch. When you're dealing with more complex color schemes, go over each area with its own local color. Working with local color quickly gives you an idea of how your finished painting will look and helps you solve any color problems from the very beginning.

Establishing Mood Through Underpainting

PROBLEM

The brilliant greens of trees, shrubs, grass, and aquatic vegetation all begin to look the same in midsummer. That's fine in nature, but in a painting you have to break them up or your work will be dull and monochromatic.

SOLUTION

Stain your canvas with an overall wash of green to set the color mood. When it comes time to use opaque pigment, keep as much variety as possible in the greens that you lay down.

In midsummer, rich, lush vegetation surrounds a pond, setting off the blue of the sky and water.

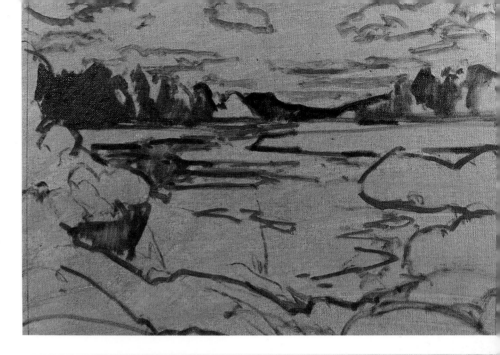

STEP ONE
Start by staining your canvas with permanent green light that has been thinned with turpentine. Let the canvas dry, then sketch the scene with vine charcoal. Now reinforce your sketch with thinned color and build up the dark areas formed by the distant trees.

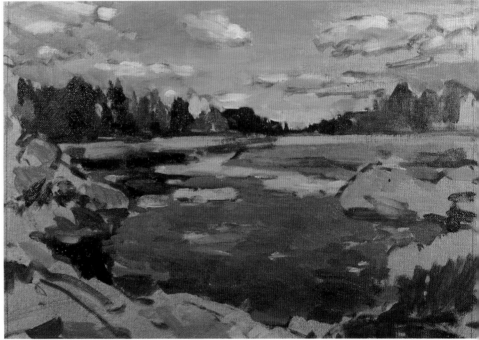

STEP TWO

The undercoating of a medium-value green gives you great freedom as you start to build up your painting. Because your mid-range values have been established, you can easily gauge the value of your lights and darks.

Working over the entire canvas, begin to introduce light and dark notes. Wherever possible, break up the mass of green with touches of other colors. Here, for example, the stream edges are developed with touches of dark brown.

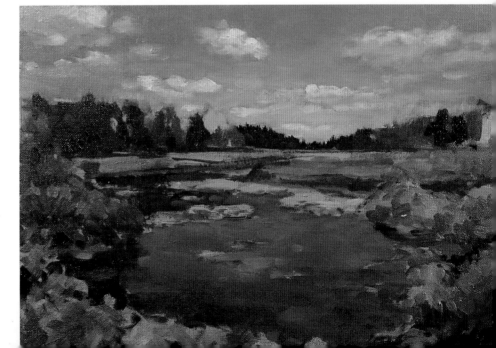

STEP THREE
Complete the clouds and the sky, then finish the dark line of trees along the horizon. That done, turn to the stream. The water itself isn't very interesting; make it come to life by developing the pattern formed by the lily pads. Now continue to develop the vegetation. Make some of it very dark—almost black—and other areas bright yellowish green.

FINISHED PAINTING

The stage is now set for detailed work. Begin by adding the grasses that dominate the foreground; to render them, use a small brush.

Next scan your painting, looking for areas that seem weak and undefined. Introduce a few additional splashes of green to the water, then paint the spindly tree that grows along the left side of the stream.

The brilliant sky, painted with cerulean and cobalt blue, white, yellow ocher, and cadmium red, acts as a foil for the lush greens that dominate the painting. Note how the sky is brightest near the horizon, and how touches of the green under-painting shine through the subsequent layers of blue.

The trees, weeds, and grasses are painted with permanent green light, Thalo green, Thalo yellow-green, yellow ocher, and—in places—with a mixture of black and yellow ocher that yields a rich silvery hue.

The dark pond is flat and uninteresting, but the lily pads that grow out of the water make the foreground lively and interesting.

ASSIGNMENT

Toning a canvas with a medium-value hue before you actually start painting can speed up the entire painting process. Experiment with the technique. Before you go outdoors, prepare several small surfaces with various colors. In the summer, try staining the canvas with a warm green, or in spring with yellowish green. In the winter, try using pale cerulean blue or light gray, and in autumn, yellow ocher.

ALPINE POOL
Creating a Focal Point

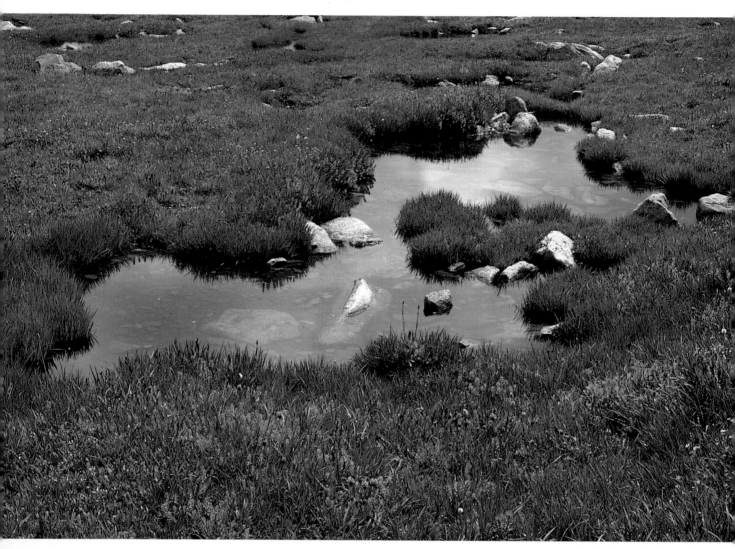

PROBLEM

Creating a center of interest is the difficulty here. The grass forms a relentless carpet of green and the water is still and dull.

SOLUTION

Break up the grass by varying its color and value as much as possible, and by using lively brushwork. Make the pool of water more interesting than it actually is by emphasizing the submerged rocks and by adding splashes of color to it.

☐ In a simple charcoal drawing place the pool, then redraw the scene with thinned color. As you work, try to indicate the contours of the grassy field. Let the canvas dry, then wash in permanent green light around the pool of water.

Continue developing the grass. In the foreground, render it with warm, rich permanent green light and ocher. As you move back in the composition, gradually make it cooler by adding touches of cobalt blue. Use brushstrokes,

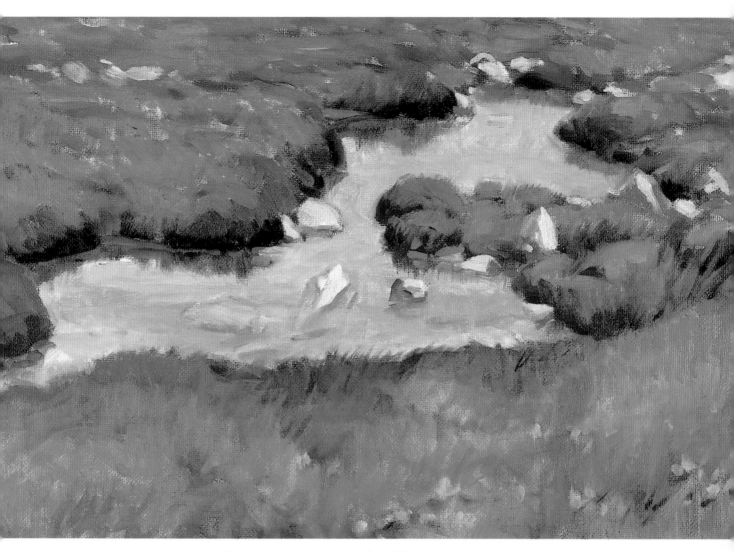

too, to set up a sense of space. In the foreground, use larger, more defined strokes; in the background, use smaller, flatter brushwork. Once the greens are established, turn to the water.

At this point, stop and sketch the submerged rocks with charcoal. Next, working around the rocks, lay in the water. Start with a pale blend of cerulean blue and white, then introduce touches of cadmium red and white and cadmium yellow and white. Finally, paint the rocks. Once their basic shapes are down, drag bits of the blue that makes up the pool over them. Now, while the water is still wet, add the dark grasses that border the water and their reflections. Separate the grasses and reflections with a thin band of brown.

Now fine tune your painting. In the immediate foreground, add touches of yellow ocher to suggest the wildflowers. Then, near the water's edge, drag green pigment slightly up over the water using a drybrush technique.

Controlling Strong Greens

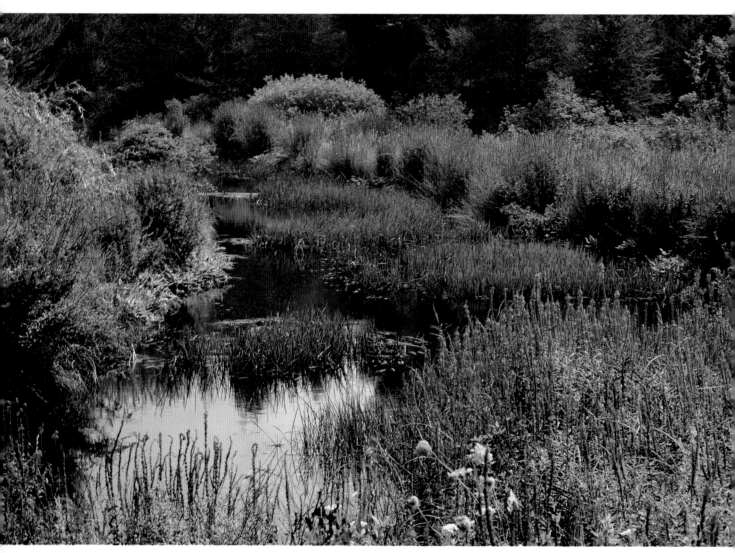

PROBLEM

At first glance, the purple flowers seem to dominate this composition. Closer study reveals that the scene is actually packed with dark, rich greens.

SOLUTION

Vary the greens as much as possible, using both warm and cool hues and light and dark values. When you lay in the flowers, do so boldly, exaggerating the patterns they form.

☐ In your preliminary drawing, get down the shape of the stream and the major shapes formed by the massed vegetation. Before you begin, analyze the same carefully. Note how some of the shrubs are round and pillow shaped, while others are treelike. Fill your sketch with as much variety as possible.

Now reinforce the charcoal sketch with thinned color and begin to lay in the greens. Start in the background. Mix a big puddle of dark wash with Thalo green and alizarin crimson. Make it really dark and it will be easier to

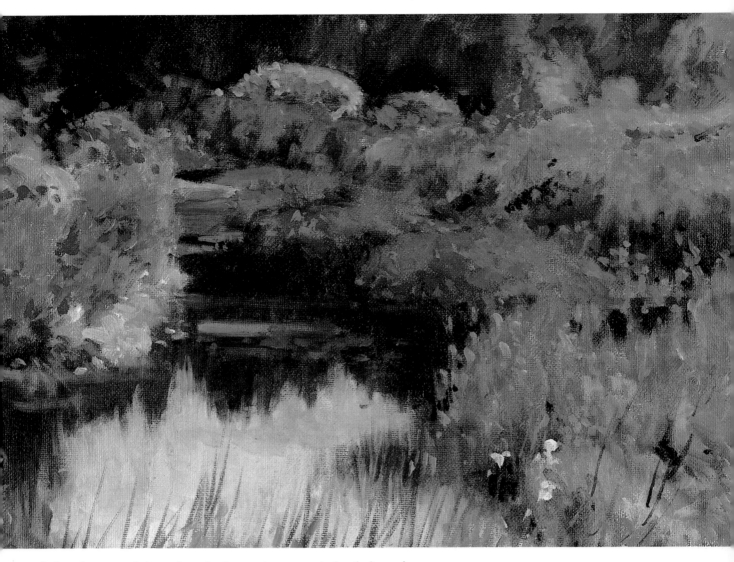

judge the rest of the values in the composition. Once the trees in the background are down, move on to the next darkest area, the reflections in the water. Again, make them as dark as possible.

The darks down, switch to thicker opaque pigment and work back into the greens. For those in the background, use cool hues and broad strokes. As you move into the foreground, use warmer greens and shorter, choppier strokes.

Now paint the water. Remember that it reflects the sky and feel free to add dabs of white to suggest clouds hovering overhead. As the stream meanders into the distance, make the water darker and cooler.

The scene is set now for the purple flowers. Mix two or three shades of purplish pink from alizarin crimson, cadmium red, white, and cadmium orange, and render the blossoms with short, broken strokes. Make the flowers in the foreground more definite than those farther back in the composition. Finally, paint the tall grasses that lie in the immediate foreground using a feathery dry-brush technique.

Highlighting a Waterfall

PROBLEM

What should be the center of interest here—the waterfall—is lost among the dense foliage.

SOLUTION

Make the waterfall larger than it actually is, then break up the foliage by using a variety of dark and light greens.

☐ In your charcoal sketch, arrange the patterns formed by the foliage and indicate the movement of the water. Next, redraw the foliage patterns with different values of thinned green paint, then quickly brush in the foliage with thinned color. Work all over the canvas, but don't try to indicate any detail at this stage.

Working back over the thin underpainting, build up the dark and light patterns formed by the foliage with thicker opaque paint. You'll want to use a variety of greens—Thalo green, permanent green light, plus mixtures of cobalt blue and yellow ocher and even black and yellow ocher. Make your brushstrokes short and lively to animate the dense vegetation and suggest its texture. When the foliage is partially painted, start to paint the stream, working back and forth between the water and the plants. Let some of the foliage creep up over the stream to indicate how the water moves backward. Here the water is painted with raw sienna, cadmium red, black, cobalt blue, and white, plus small touches of Thalo green.

Now turn to the foreground. To render the confusing tangle of vegetation that dominates the immediate foreground, use crisp, definite brushstrokes. Lay one stroke over another to define the mass of vegetation and give your strokes a definite sense of direction, too.

Now stop and evaluate your painting. If the distant foliage looks too confusing, try to simplify it. If the grasses in the foreground seem too simplified, go back and define them further. Finally, add dark and light accents to the water to show how the falling water catches the light.

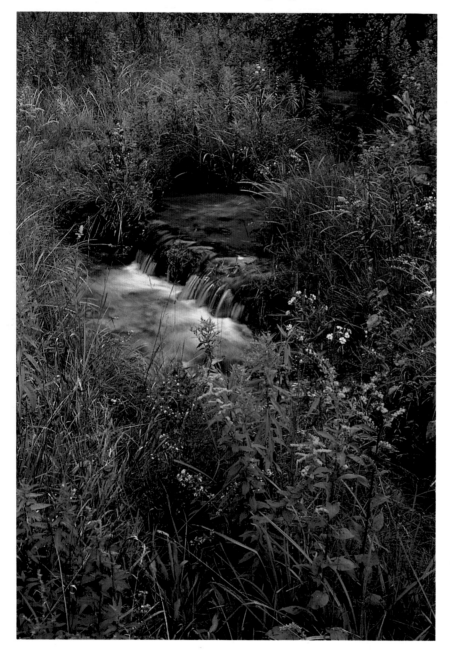

Set amidst lush green foliage and brilliant wildflowers, a rushing stream splashes over a rocky ledge.

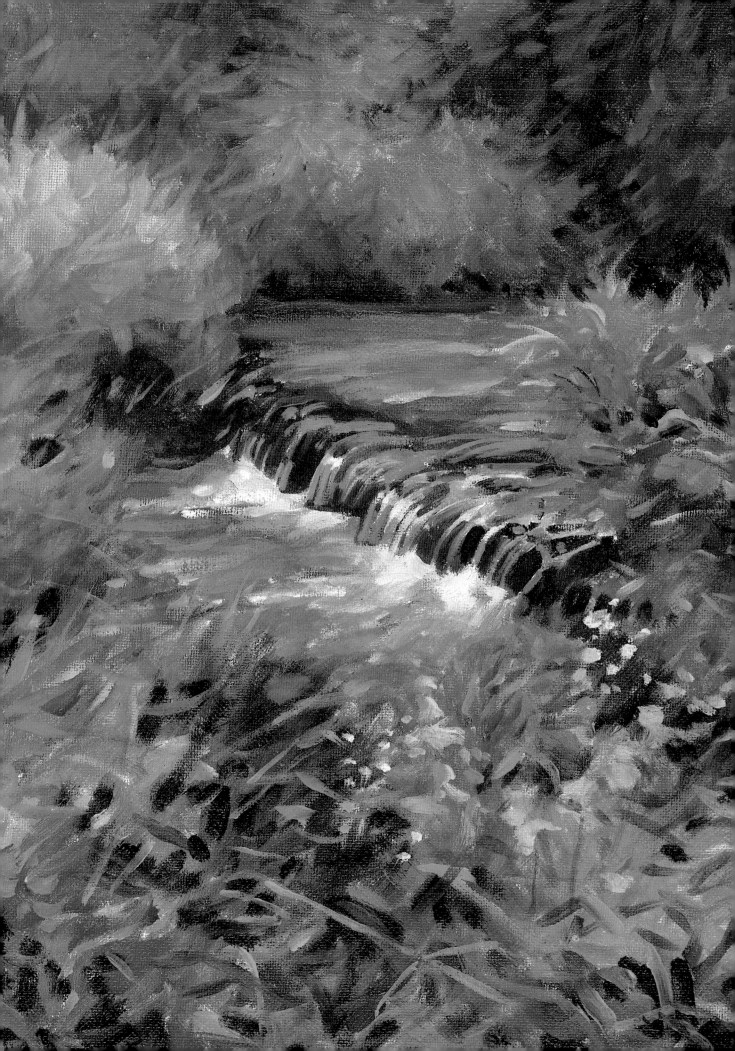

Learning How to Paint Rapidly Moving Water

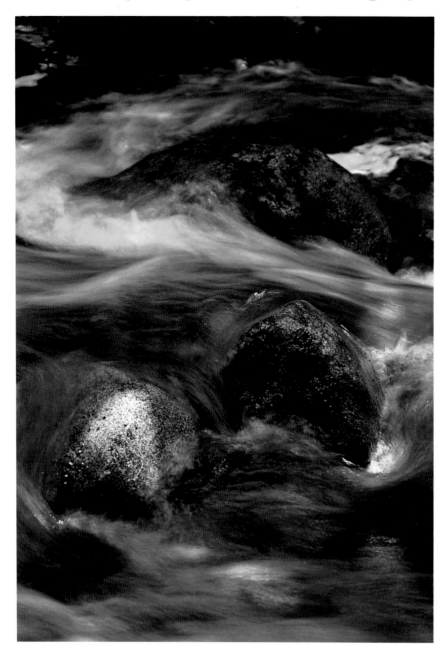

PROBLEM
The water is soft and foamy; the rocks are hard and angular. The challenge lies in capturing both qualities in your painting.

SOLUTION
Think in terms of overall pattern. In your charcoal sketch, get down the shapes of the rocks and the movement that sweeps through the water, then as you paint, work back and forth between water and rocks.

STEP ONE
Begin your preliminary charcoal sketch by placing the rocks, then rapidly draw the patterns formed by the moving water. Next dust off the drawing, then reinforce it with thinned color. Use burnt umber to render the outline of the rocks, and cobalt blue for the water.

Soft, foamy water cascades rapidly over sun-struck rocks.

STEP TWO
Using turp washes, start to plot out your colors and values. First, develop the dark, shadowy portions of the rocks with burnt umber and the dark lines that rush through the water with Thalo blue. For the time being, the white of the canvas will represent the lightest values.

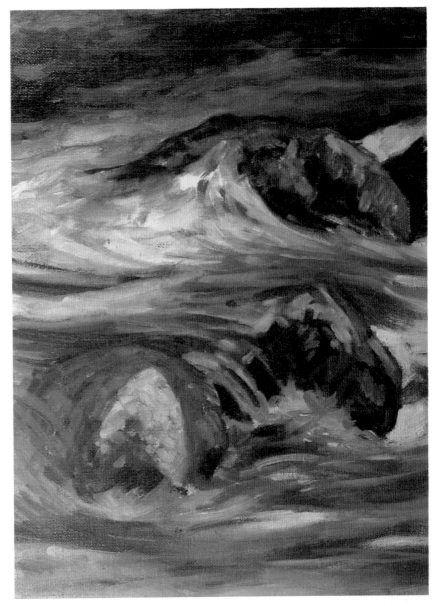

STEP THREE
Working from dark to light, and with thick opaque pigment, build up your painting. As you work, let your brushstrokes help you separate the rocks from the water. To render the rocks, use short, choppy strokes; for the water, sweep in long, fluid strokes. Keep a careful eye on the bright white foam and on the highlights that flicker across the water; they are the key to making your painting bright and lively.

FINISHED PAINTING

Sharpen the edges of the rocks and introduce more touches of color into the water. At the very end, blend together white and yellow ocher and reinforce the foam that ebbs around the rocks.

DETAIL

The water is built up of many colors—cobalt and Thalo blue, Thalo green, cadmium red, white, Mars violet, alizarin crimson, and even cadmium orange. But it's the brushwork, not the colors, that makes the painting vibrant. Note how the strokes vary: Some are long and fluid, others short and dramatic.

ASSIGNMENT

Execute several close-up studies of water. For each study, focus in on a square foot or less of water, then draw the composition slowly and carefully, trying to capture every detail. Look for submerged rocks, bits of vegetation, and the patterns formed by the mud, stones, or weeds that lie beneath the surface. If the subject you select is likely to change rapidly, try photographing it, then work from enlargements back in your studio. Sketching these close-ups will train you to really look at what you see. You may find, too, that you like your studies well enough to translate them into full-size oil paintings.

Taming an Overly Dramatic Scene

PROBLEM

The contrast between the water and rocks is so great that it will be difficult to achieve a realistic look. The scale is odd, too. What at first seems huge is really a close-up view of a tiny rivulet of water.

SOLUTION

Simplify the rocks to lessen their drama, then use bold brush-strokes to indicate the movement of the water. In your finished painting, the water will stand out clearly against the dark, mossy backdrop.

☐ Sketch the scene with charcoal, then reinforce the drawing with a brush and thinned color. In your charcoal and oil sketches, try to indicate the three-dimensional quality of the rocks and their horizontal and vertical planes. Don't get too involved in detail, though. There will be plenty of time for that later.

Now begin to work with opaque color. First study the scene. Note how the vertical rock surfaces are dark and cast in shadow and how the horizontal rock surfaces reflect the sunlight. To render the vertical planes, use cool hues; for the horizontal planes, rely on warmer colors. Once you've established the basic rock shapes, quickly brush in the rushing patterns formed by the water.

Now turn to the moss that clings to the rocks. You don't want to paint every detail; if you do, you'll steal attention away from the water. Instead, simplify the greens you see, and use short, broken strokes to suggest the texture of the moss.

Once you've completed the moss, turn to the water. You've already laid down its basic pattern; now embellish what you've begun. First, suggest the rocks that lie beneath the falling water by dragging touches of cerulean blue and Mars violet over the white. Next, intensify the patterns of the water in the foreground. Load your brush with color, then quickly pull the brush over the canvas, following the motion of the water. Toward the edges, soften the white with touches of violet and blue.

As a final step, sharpen the edge of the large rock in the right foreground, then soften the edges of the splashing water.

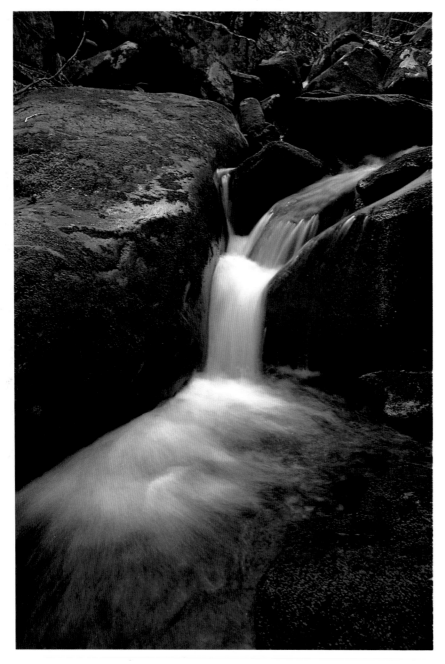

A rivulet of glistening white water rushes over moss-covered rocks.

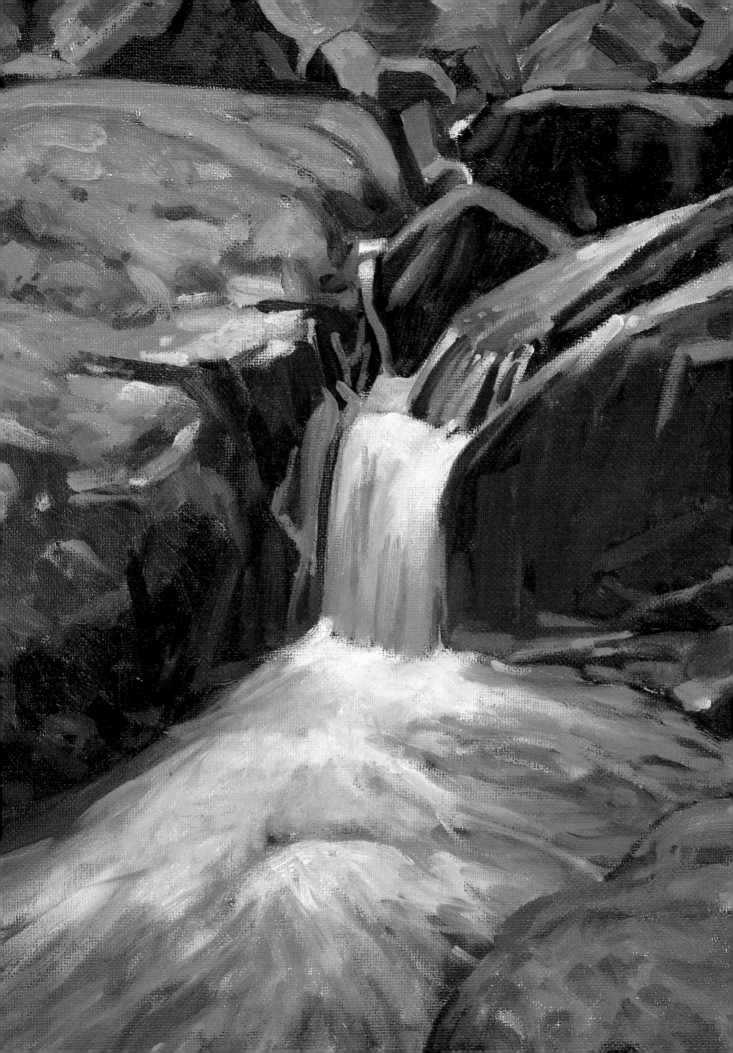

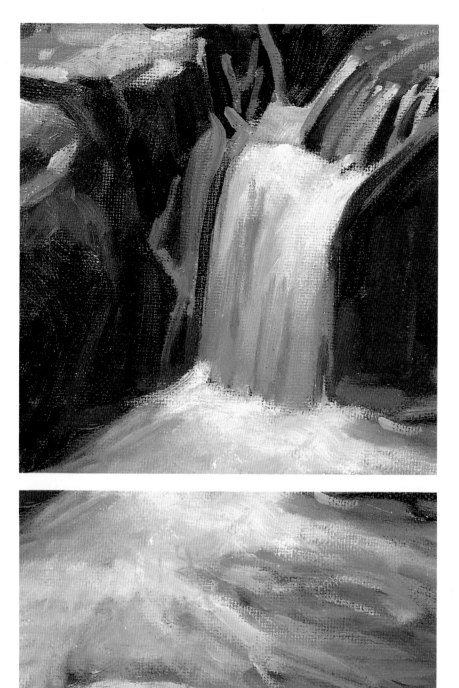

DETAIL
Touches of blue and violet are pulled through the white paint to suggest the rock that lies beneath the falling water. Where the falling water meets the pool below, vigorous brushstrokes clearly separate the two areas.

DETAIL
Pure white paint suggests the frothy water at the bottom of the falls. Laid in with strong, dramatic brushstrokes that follow the motion of the water, the white is muted as it moves outward toward the edges of the pool.

Reorganizing What You See

PROBLEM
There are so many rocks covered with so much moss that it becomes hard to understand the scene. If you follow what you see literally, your painting will be confusing.

SOLUTION
Feel free to rearrange the composition. Make the rocks in the foreground larger than they actually are and simplify those in the background.

☐ Make a careful drawing of the rocks with vine charcoal, simplifying their shapes. As you work, think in terms of dark and light. Even in this early stage, begin to develop the painting's overall design. Dust off the charcoal drawing, leaving just a pale image on the canvas. Now cover the pale lines of your charcoal drawing with thinned color. After you've reinforced your sketch, brush in the dark shadowy portions of the rocks with a wash of raw umber. It's important to establish the darks right away; they'll help you visualize the overall composition.

Working with heavier color, develop the dark and light patterns on the rocks with gray mixed from black and white, plus raw umber, yellow ocher, burnt sienna, and touches of Mars violet. Don't try to add too much detail now; just build up the individual rocks. Next, lay in the soft, diffused background.

Working from dark to light and wet-in-wet, start to paint the falling water. For the highlights, use pure white; for the darker passages, use mixtures of white and Thalo blue. The lights and darks established, add subtle streaks of yellow ocher to tone down the whites, and streaks of brown to indicate the brown rocks that lie beneath the water.

Working with Thalo green and cadmium yellow, plus just a bare touch of white, add the bright moss that clings to the rocks. Concentrate the green in the foreground to make it the center of attention.

Wait until the surface is almost dry, then go back and strike in the distant tree trunks and make any necessary refinements in the water and rocks.

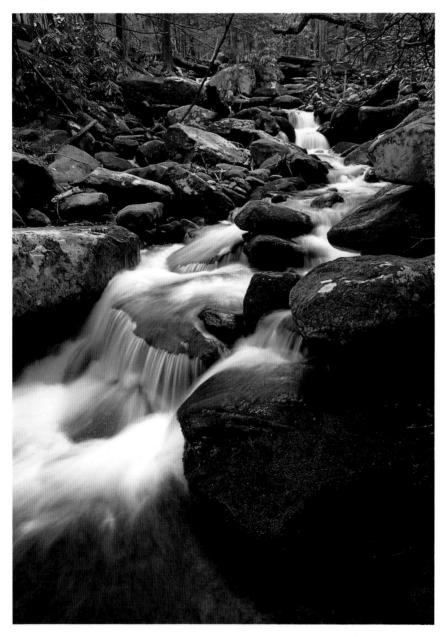

Cool water pulses over a jumble of moss-covered rocks.

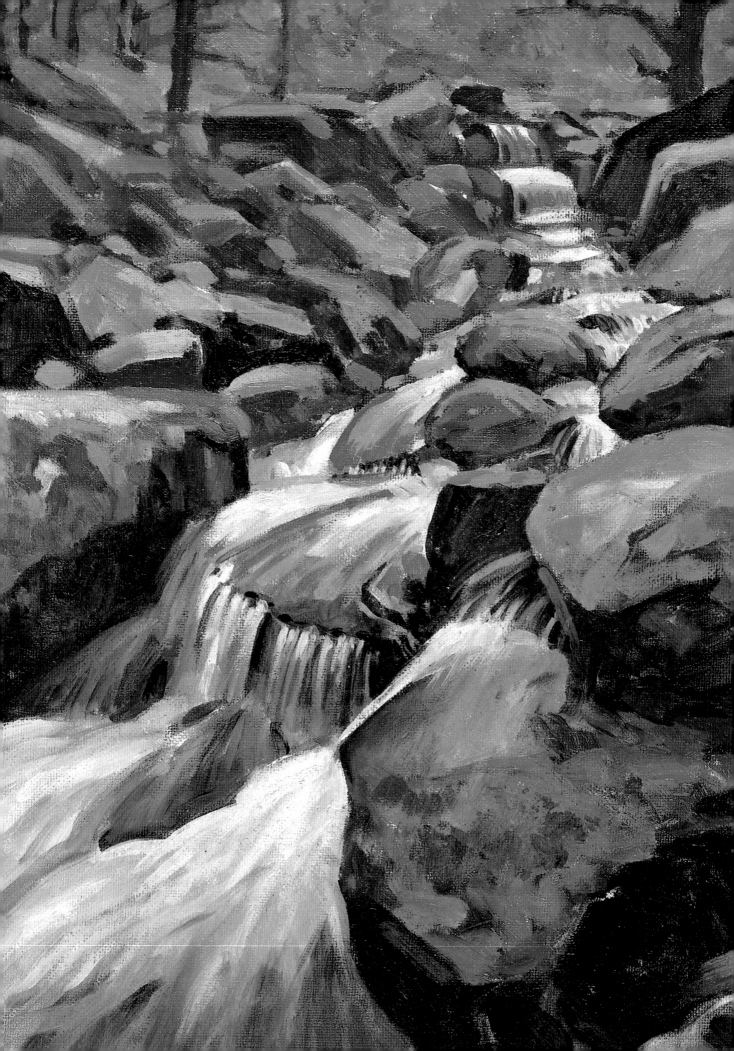

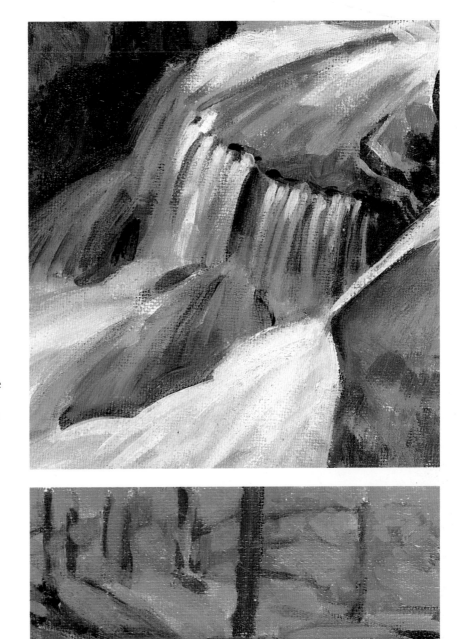

DETAIL

The water is painted in stages. First the lights are brushed in with pure white, then the darks are added with blue and white. Next, touches of yellow ocher subdue the strong white passages, and the underlying rock surfaces are laid in with earth tones. At the very end, when the surface is almost dry, touches of dark brown pigment are added to indicate the point where the water starts to pour over the rocks.

DETAIL

Rocks and trees in the background are simplified to help organize the busy landscape. Simple, single brushstrokes are used to apply neutral tones—not too dark, not too light. Details are minimized, and some, such as the leafy branches, have been eliminated entirely. Bright greens and white highlights used elsewhere to attract attention are reserved for the foreground and a few selected spots.

47

Painting a Delicate Waterfall

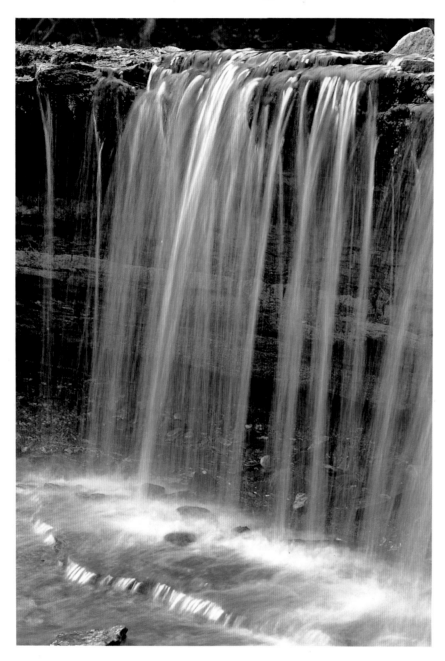

PROBLEM

The wall of rock that lies behind the waterfall can be easily seen through the water. To create a painting that works, you'll have to successfully depict the transparent nature of the water.

SOLUTION

Paint the water carefully, faithfully following what you see. Before you begin, execute a detailed charcoal sketch of the waterfall, then use it as a guide when you start to paint.

STEP ONE

Sketch the scene, concentrating on the waterfall. Before you begin, analyze the scene and try to pick out each strong stream of water. When your sketch is completed, go over it with thinned color. At this point, start to brush in the dark rock behind the waterfall, again working with thinned color.

Gently falling water forms a broken curtain of white over a dark rocky cliff.

STEP TWO

Working all over the canvas, establish your basic colors, values, and shapes. Throughout this stage, continue using thinned color, and make sure that you don't lose the underlying drawing. When you come to the waterfall and rocks, work back and forth between the two. Don't let the individual streams of water become too regularly spaced, either.

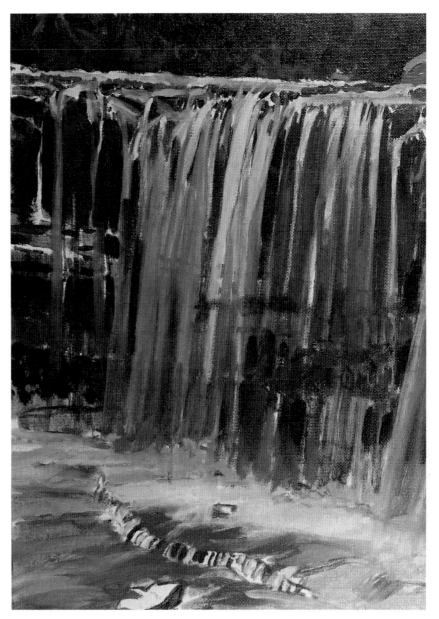

STEP THREE

Now strengthen the waterfall. Mix your pigment with plenty of painting medium, then softly apply these glazes of color over what you have already established. At the same time, build up the rocks that lie behind the wall of water. To really capture the transparency of the water, you'll have to apply several layers of glaze. After you apply each layer, let it dry for a minute or two before you move on.

Finally, strengthen the foliage at the very top of the canvas with opaque color and start to build up the pool of water beneath the falls.

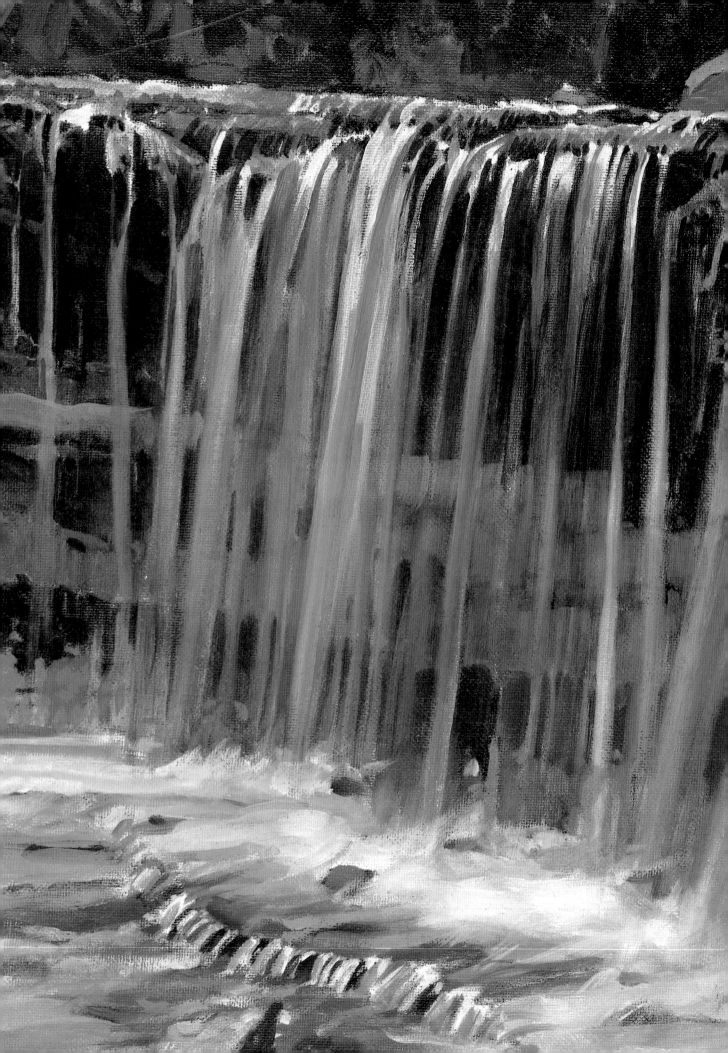

FINISHED PAINTING

The brightest, lightest areas in this composition are made up of highlights formed where sunlight hits the water. Sharpen these areas now. Mix white pigment with the barest touch of cobalt blue and bring the highlights of the waterfall and those at its base into focus.

As a final step, develop the patterns that lie in the rushing water in the foreground.

DETAIL

Instead of working with thick pigment, try using thin, delicate glazes the next time you paint a waterfall. Here each stream of water is carefully laid onto the canvas with a long liquid stroke. Through these strokes, you can see those that were applied earlier. The end result: the feel of glistening, transparent water, struck with brilliant white highlights.

Capturing the Movement in a Shallow Stream

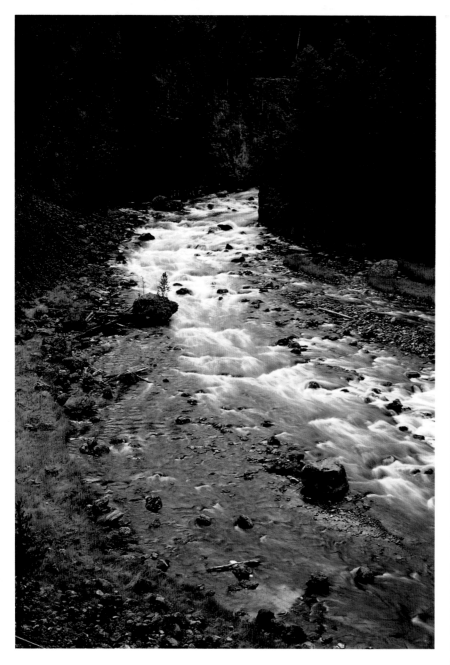

PROBLEM

All of the excitement in this scene comes from the glistening, rushing water. You can't pay too much attention to the dark trees that border the stream.

SOLUTION

Simplify the dark trees in the background and the bright golden grass on the left, then add as much detail as possible to the water.

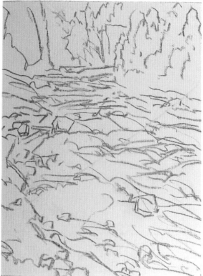

STEP ONE

Work out all the compositional details in your preliminary sketch. Working with soft vine charcoal, loosely lay down the contours of the stream, then establish the shapes of the trees and the shoreline. Finally, indicate the subtle depressions and elevations that mold the stream bed and the major rocks.

In autumn, a shallow stream rushes quickly over rocks and stones.

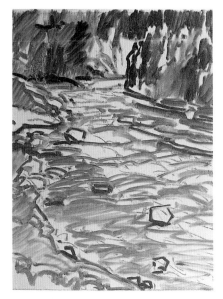

STEP TWO

Dust off the canvas, then reinforce your drawing with a small bristle brush that has been dipped into thinned color. Use the local color that dominates each area of the composition to set the color mood of your painting: yellow ocher and burnt sienna along the stream, cobalt blue in the water, and permanent green light for the trees. Now quickly brush in the large masses of dark color, again with thinned color. For the time being, let the white of the canvas represent the lightest values.

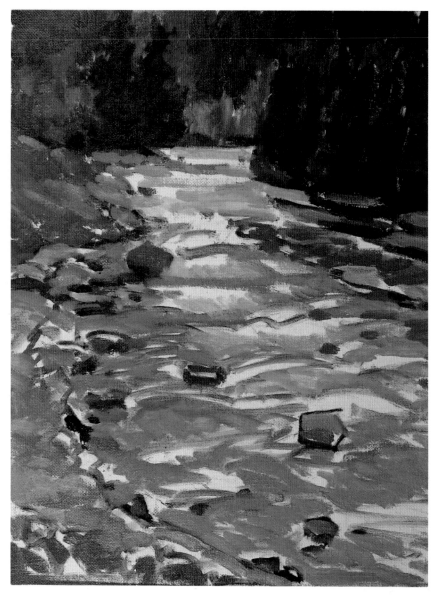

STEP THREE

Working from dark to light and with thick opaque paint, go back over your color sketch. In this stage, aim at capturing the exact colors and values that you want to see in the finished painting. Start with the trees in the background, then move on to the stream banks. Finally, turn to the water. As you render it look for large shapes and patterns. Here, yellow ocher and cadmium orange suggest the ground, and the trees are established with Mars violet, white, cobalt blue, Thalo green, permanent green light, and yellow ocher.

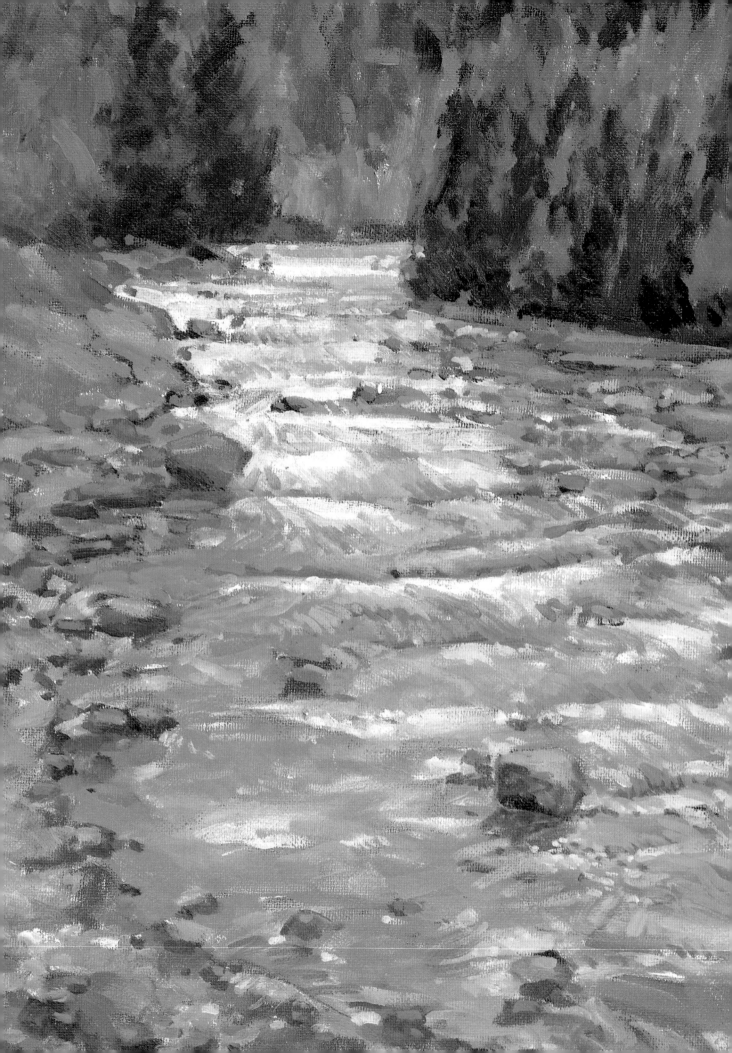

FINISHED PAINTING

Add detail to the water and to the land that surrounds it. For the water, mix together a light hue of gray, then tone it with Mars violet, cerulean blue, and cobalt blue. Apply a good-size dab of pure white to your palette, too. As you work, move back and forth between the whites and the blues, and use loose, overlapping strokes that follow the direction of the rushing water.

Now stop and evaluate your painting. Pay special attention to the ocher grasses in the fore-ground. If they are too light, they will run into the water visually. Remember, the highlights in the water should be the brightest, lightest areas in the finished paint-ing. If they are too dark, go back and reinforce them with splashes of pure white, then pull touches of pale blue and purple over the edges of the white strokes to integrate them into the rest of the painting.

DETAIL

Flickers of white dance over the top of the water. Throughout the entire painting process, areas of white canvas are left clean to indicate the lightest, brightest portions of the composition. The highlights are painted at the very end, then toned down slightly with overlapping strokes of pale blue and purple.

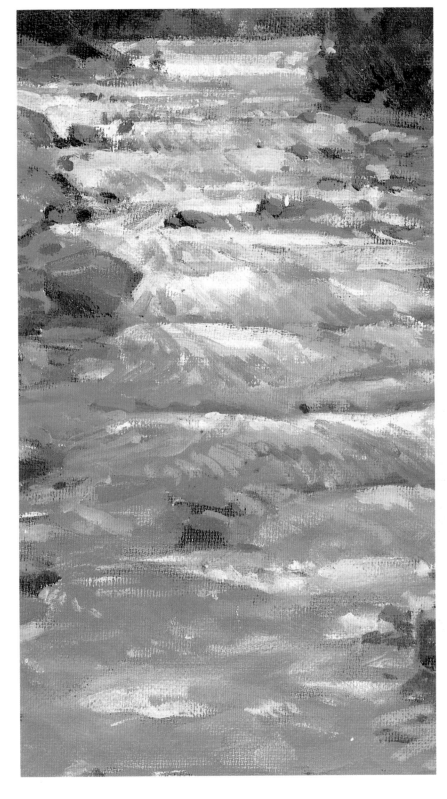

Sorting Out a Maze of Landscape Elements

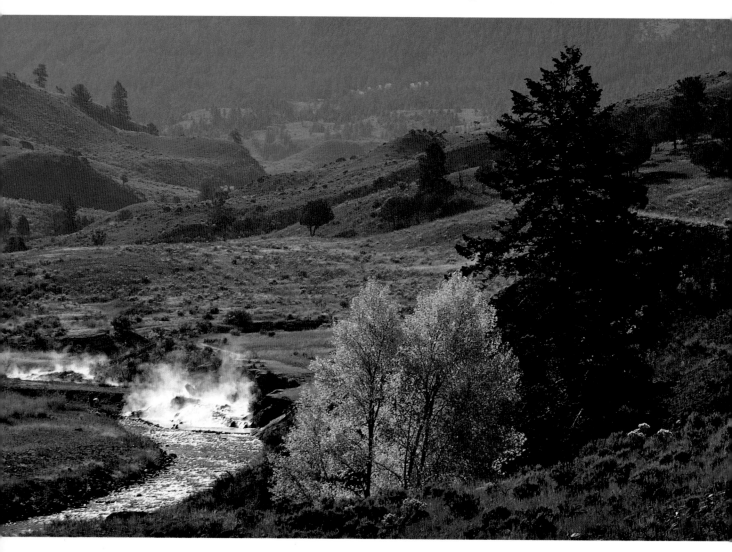

PROBLEM

The most interesting element in this landscape is the hot spring, but set against the immense landscape it loses power. You'll have to play down the rest of the scene if the spring is to stand out.

SOLUTION

Simplify the distant landscape and let the brilliant gold trees in the foreground direct attention to the spring.

☐ Place the major elements of the composition on the canvas with charcoal, then go over the lines of your drawing with thinned color. Use raw sienna for the hills in the foreground, Thalo green for the dark tree, yellow ocher for the brilliant trees, and Mars violet for the hills in the distance.

Once your framework is established, quickly brush in thin washes of color to build up color and value throughout the painting. At this point, let the white of the canvas represent the hot spring's spray.

Let the canvas dry, then switch to heavier, opaque pigment. Working from dark to light and wet-in-wet, adjust the colors and

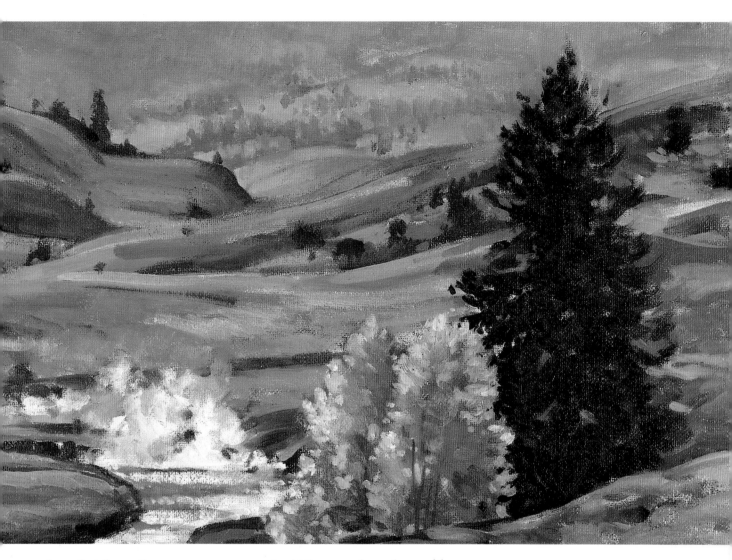

values that lie on the canvas. Since you'll be working rapidly, consider using a gel or paste medium—it will speed up the drying time, making it easier for you to move rapidly.

Start with the darkest element, the large tree in the foreground. Next, brush in the medium values—the hillsides and the distant landscape.

Finally, put down the brilliant trees in the foreground and the river itself. Here the large tree is rendered with a mixture of Thalo green and alizarin crimson. The hills and trees in the distance are made up of cobalt blue, Thalo green, Mars violet, and white. The warm hills in the foreground

and middle ground are done with Mars violet, cadmium orange, yellow ocher, raw sienna, and white. The golden trees on the right are painted with cadmium orange, yellow ocher, and a dab of cadmium red—don't add too much white. Finally, the water consists of cerulean blue, Thalo green, and white.

As a final step, subdue the distant landscape. Glaze the entire area with a goodly amount of painting medium that's been tinged with cobalt blue. Finally, pull out the whites of the hot spring using a drybrush technique.

Mastering Soft, Gentle Mist

PROBLEM

The mist may be delicate, but the rest of the scene is full of stark contrasts. If you render the composition too realistically, the mist will be lost.

SOLUTION

To capture the special feel of this scene, downplay the drama of the overall landscape.

☐ Using vine charcoal, establish the movement of the river. Make sure that it looks realistic by concentrating on the way it moves back into the landscape. Now sketch the distant trees loosely, without adding too much detail. Finally, add the trees in the foreground. Dust off the loose charcoal and redraw the composition with thinned raw umber.

Now go over the entire canvas with thinned color, establishing the overall mood of your painting. Get the darks down first; on a white canvas, any color looks dark, so rendering the very darkest values right away makes it easier to gauge your light and medium tones.

Switch to heavier color now and start to build up the darks. First scrub in the tree-covered hills in the distance, then slowly build up the browns of the land. As you paint, let your brush-strokes mimic the contours of the land. When you approach the central portion of the canvas, work with lighter color: Doing this, you'll pull attention toward the water and the rising mist.

Lay in the water. While the pigment is still wet, take a dry bristle brush and scrub the paint upward, over the river banks to capture the feel of the mist. If necessary, add a little white to the canvas to make the floating mist seem lighter still.

Finally, add the dark trees in the foreground. When it comes time to lay in all the small branches that spring from them, use a small, round, pointed brush and add plenty of painting medium to your pigment.

At the very end, use a dry-brush approach to suggest the small branches and leaves that radiate outward from the branches.

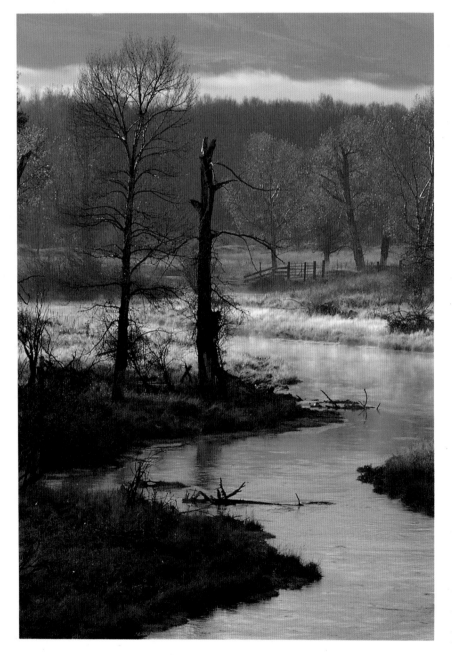

In fall, as the temperature dips, mist rises as a warm river meets the cold, frosty air.

Painting Water in Early Morning Light

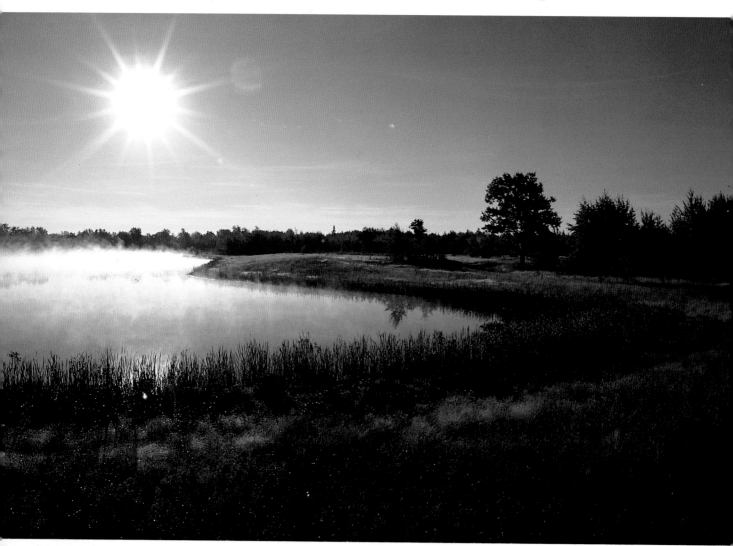

PROBLEM

Two things make this scene arresting—the golden summer light and the soft mist. They have to be the focus of your composition.

SOLUTION

Lighten the foreground so that it doesn't overpower the rest of the scene, and carefully control all of your colors and values.

In early morning, a summer sun explodes over the clear blue water of a pond, and a gentle mist rises in the distance.

STEP ONE

Execute a rapid charcoal sketch to establish the overall composition. Concentrate on the sweeping line of the shore and the patterns that run through the sky and the water. Don't get bogged down with detail—the scene is really very simple.

STEP TWO

Dust off the charcoal and redraw the composition with thinned color, quickly establishing the local color of each area. Use Thalo green for the trees, cobalt blue for the water, and burnt sienna for the ground. Now brush in the darks of the distant trees and the grasses that line the shore. At this point, you should have a good idea of the overall color mood of your painting and the way the colors are balanced within the composition.

STEP THREE

With heavier color, paint the sky, working loosely around the trees that run along the horizon. If you cover up part of the trees, don't worry; just go back and add them later on. Here the sky is rendered with cobalt blue, Thalo green, and cerulean blue. Near the horizon, a mixture of yellow ocher and white is introduced. Now paint the trees with Thalo green and alizarin crimson, the distant shore with yellow ocher, and the foreground grasses with Thalo green, cadmium orange, burnt sienna, and yellow ocher. Finally, paint the water, using the same colors that you used for the sky. While the paint is still wet, pull it up over the trees to suggest the rising mist.

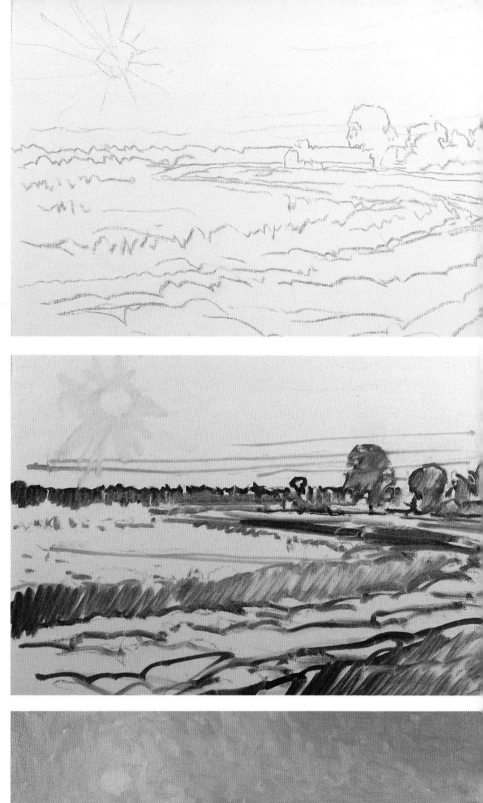

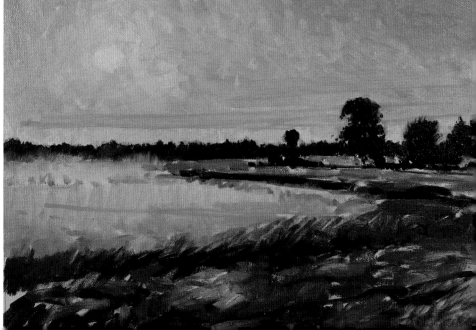

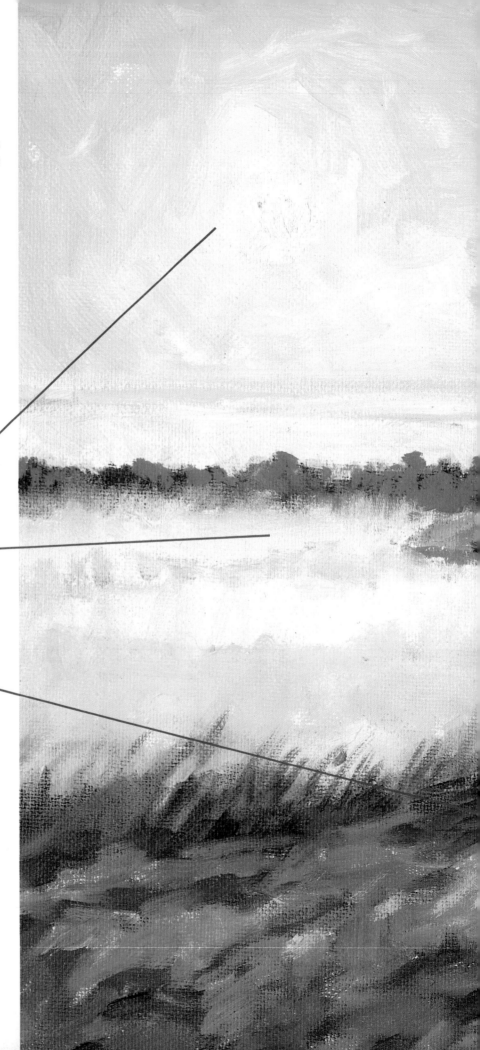

FINISHED PAINTING

Moisten your brush with a pale mixture of cadmium yellow and white, then render the sun. Here it's painted simply, but if you prefer, make it as dramatic as it is in the photograph. Now, using the same hue, add the reflected golden glow to the water.

Now look at the painting as a whole. Here the sun seems to float unnaturally against the sky, so soft strokes of cerulean blue, cadmium yellow, and white were added around it, helping it to blend in with the rest of the composition.

All around the sun, gentle strokes of cerulean blue, cadmium yellow, and white have been added to act as a transition between the yellow of the sun and the blue of the sky.

While the water was still wet, the pigment was dragged up, over the trees, to suggest the rising mist. Later, touches of cadmium yellow and white were added, flooding the water with the same warmth that bathes the sky.

The colors in the foreground are strong and rich, but they don't detract from the power of the water and the sky because their values are controlled. Note how much lighter they are in the painting than they actually appear in nature.

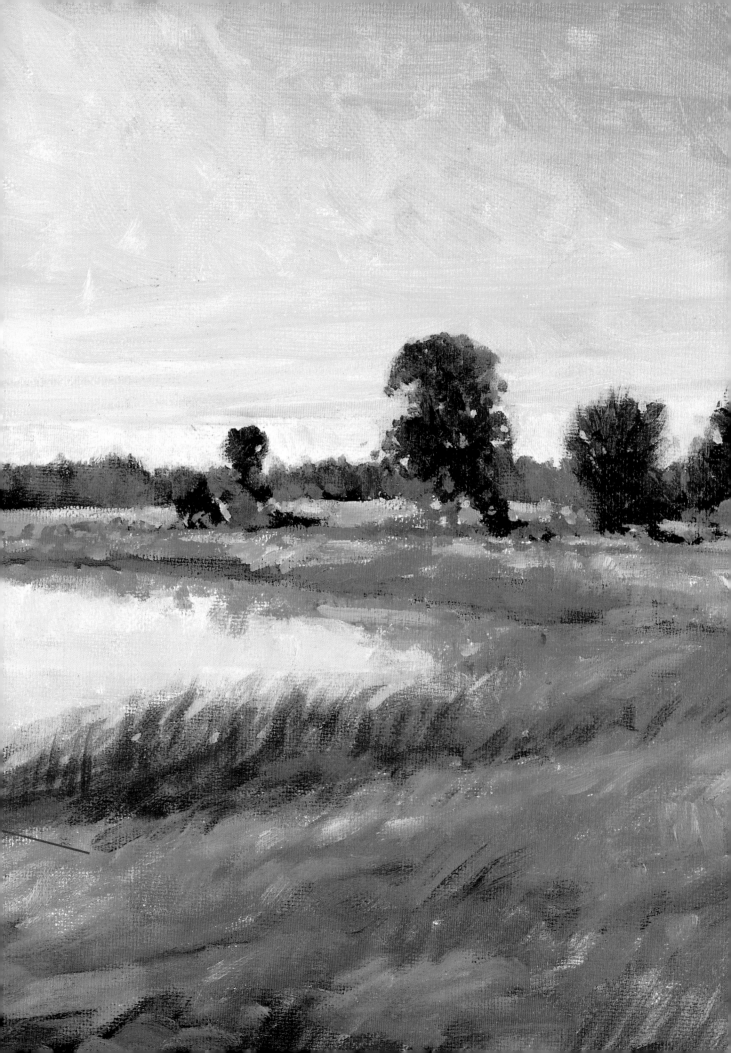

Experimenting with Fog

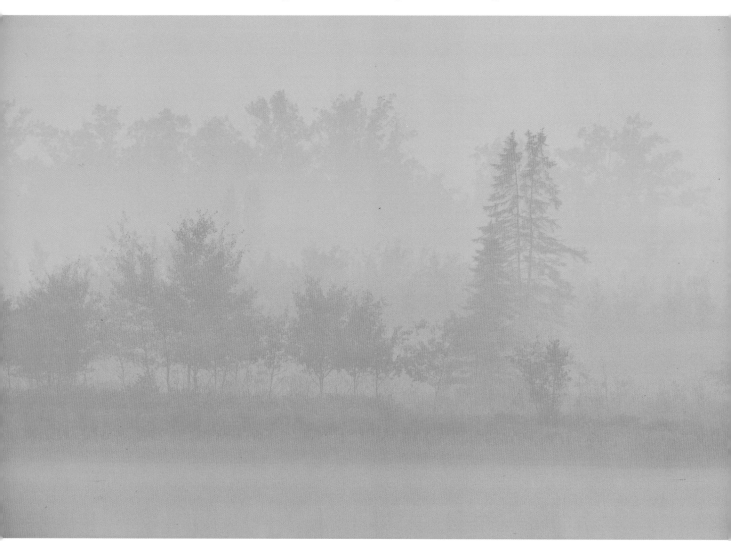

PROBLEM
Fog softens forms and reduces color and value. Any harsh note—a color that's too strong or a value that's too dark—can make your painting look artificial.

SOLUTION
Work wet-in-wet with just four or five colors, and divide the composition into three distinct zones—background, middle ground, and foreground. Constantly examine your values as you paint.

☐ Execute the simplest of sketches; just indicate the outlines of the trees, then go over your charcoal drawing with a wash of pale blue.

Now prepare your palette. Squeeze out cerulean and cobalt blues, plus black and white, yellow ocher, and a little cadmium red and Thalo green.

Using washes of thinned color, lay in the rows of trees. Start in the distance with the lighter trees, then slowly move forward. Don't try to show any modeling—you wouldn't see any on such a foggy day.

Thick, cold fog presses down against the land, obscuring the trees that grow along the shore of a lake.

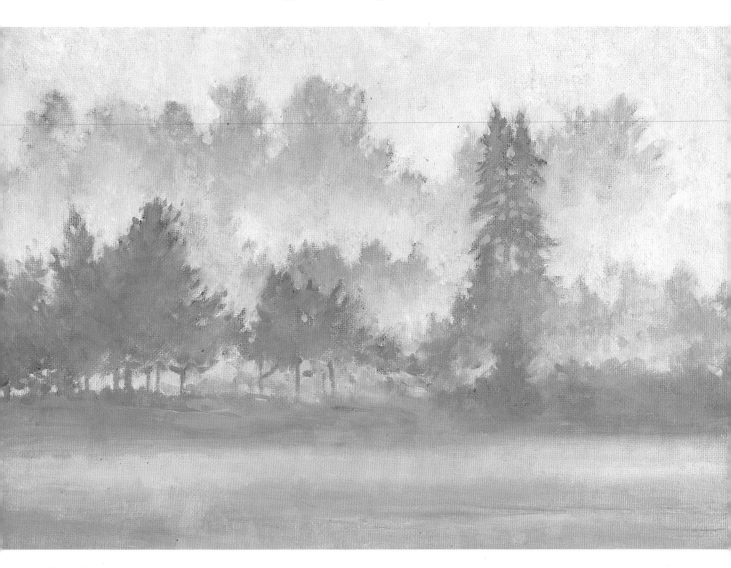

Switch to opaque pigment. Apply the color with short, choppy strokes, and vary the color within each area to add an atmospheric mood. To suggest the fog, try scumbling lighter colors over parts of the trees.

Check now and make sure that your painting makes sense. Since you've been working wet-in-wet, it may be too loose in places. If so, refine the shapes of the trees, but don't introduce any sharp lines.

Finally, paint the water in the foreground with long, sweeping horizontal strokes.

ASSIGNMENT

A variety of supports are available to the oil painter other than prepared canvas boards. Smooth Masonite is great when you are painting an intricate detail and don't want the weave of canvas to interfere with your subject.

Or try working on watercolor paper. Its texture can help you capture a variety of effects. Prime the paper with thinned acrylic mat medium, let the paper dry, then start to paint.

You can also stretch your own canvases. It's less expensive than using boards and lets you to select any weave you want, from the smoothest to the roughest.

Balancing a Soft Background and a Focused Foreground

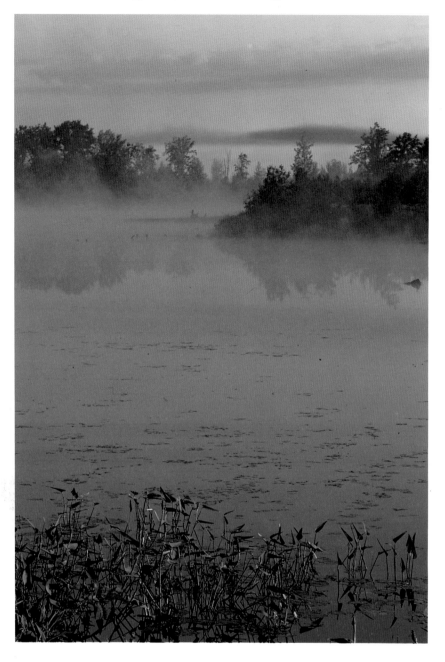

PROBLEM

In the distance, soft mist obscures the landscape, while closer to shore, everything is crystal clear. How can a painting look unified if it contains such different elements?

SOLUTION

Let the water act as a bridge between the two areas. In the background, keep it soft and light, then as you move forward, make it darker and richer.

STEP ONE

Sketch the scene, then go back over the lines of your drawing with thinned color. Next, working with thinned color, lightly brush in the flat shapes of the distant trees and their reflections. Working with a small bristle brush, suggest the grasses in the foreground and the patterns in the sky.

In midsummer, cool morning mist rises from the surface of a pond.

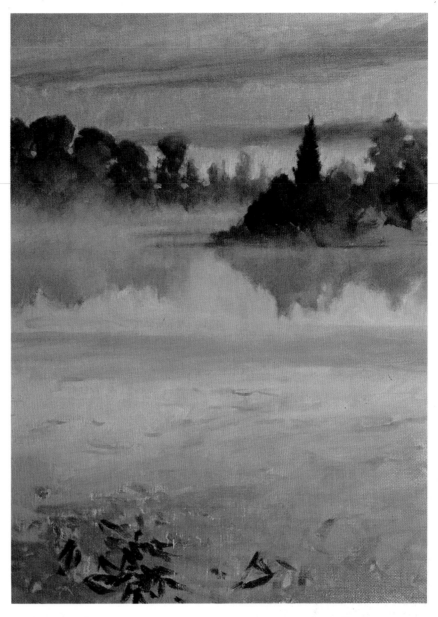

STEP TWO
Establish the rest of the painting with thinned color. Since you are working with turp washes, don't worry about obscuring what you've already done; you'll find that the diluted pigment floats easily over your preliminary work. Work with just three colors, cerulean blue, cobalt blue, and Mars violet. Now let the surface dry.

STEP THREE
Working wet-in-wet, with opaque pigment, reinforce what you've done in Step Two. Continue working with cerulean blue, cobalt blue, and Mars violet, but add streaks of permanent green light and cadmium yellow to the sky, and touches of permanent green light to the water. For the trees, blend Mars violet together with the green and gently dab the paint onto the canvas. Keep the reflections of the trees lighter than the trees themselves; the fog makes them even lighter than they would usually be.

FINISHED PAINTING (overleaf)
Lighten the sky with long horizontal strokes of cadmium yellow and permanent green light, then mix a little white into your yellowish-green pigment and sweep the color into the water around the reflections of the trees.

Finally, add the vegetation. Working with Thalo green, permanent green light, and a little burnt umber, and with a small brush, carefully paint the stems and the leaves in the foreground. At the very end, add dashes of dulled green to suggest the leaves that float behind the vegetation in the immediate foreground.

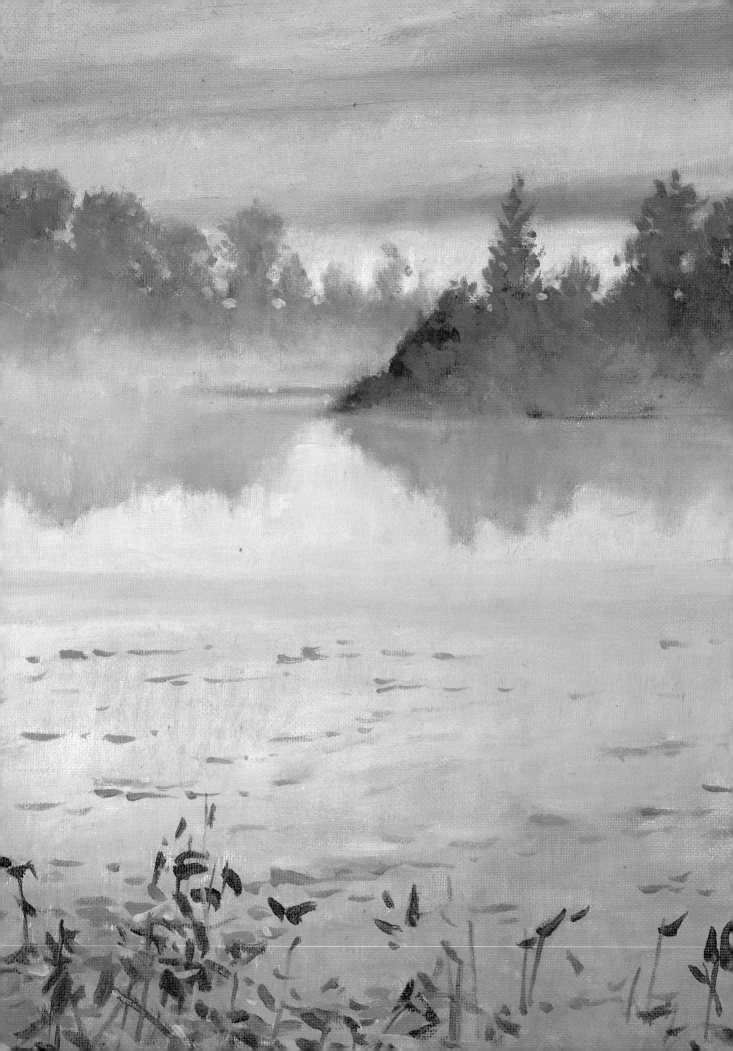

Enlivening Monochromatic Greens

PROBLEM

What at first glance may look like a mass of monochromatic green is actually rich in color. What's more, the pattern formed by the grasses is extremely complex.

SOLUTION

To capture the complexity of the grasses, execute a detailed drawing. Then, when you start to paint, try to capture every small shift in color and value.

☐ With a charcoal pencil, create a careful drawing of the swirling grasses, then spray the canvas with a charcoal fixative. Now tone the entire canvas with a wash of thinned permanent green light, let the surface dry, and then strengthen the drawing with a small pointed brush and a darker shade of thinned green.

Prepare your palette with permanent green light, Thalo green, cobalt blue, cerulean blue, cadmium orange, and yellow ocher; then, with opaque pigment, work back over the toned canvas, developing the surface of the water. Work into the area occupied by the grasses, but try not to cover up too much of your drawing.

Now it's time to turn to the vegetation. At first, try to isolate overall shapes, and lay them in loosely. When they are down, start work on individual blades of grass. Try using a special brush, a fine, long-haired, round one called a rigger or scriptliner. It's perfect for capturing the sinuous lines of the grasses, both because of its shape and because it will hold a good deal of paint. Add plenty of medium to your pigment to keep it pliable, then start working. Layer your strokes over one another, working back and forth between the grasses and the water. To keep the greens lively, repeatedly mix small amounts of color, varying each batch slightly.

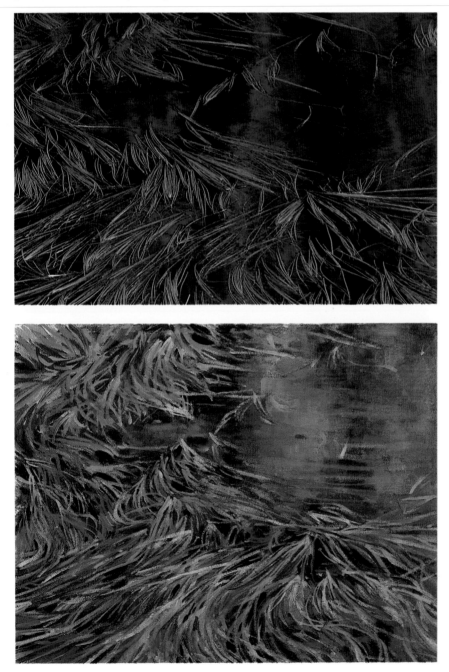

In late summer, vegetation forms an elegant, undulating pattern as it floats on the surface of a pond.

Making Sense out of Abstract Patterns

PROBLEM

The patterns formed by the ripples are extraordinarily complicated. Deciphering what you see, then translating it into a painting, will be extremely difficult.

SOLUTION

Work slowly, concentrating on overall pattern. Don't try to copy what you see slavishly—use it instead as a general inspiration.

☐ Softly lay in the large lines formed by the ripples with soft vine charcoal, ignoring all the details. Next, spray the sketch with a charcoal fixative and stain the canvas with a thin gray wash.

With heavier color, begin to build up the lights and darks. Don't let the patterns become too regular! For the time being, the toned canvas will stand for all your medium values.

The overall composition roughly laid in, start to fine tune your work. Work wet-in-wet, moving back and forth between the lights and the darks. While the surface is still wet, take a dry brush and sweep it horizontally across the canvas to suggest the action of the water and to soften any harsh lines.

Now stand back from your painting and examine the value scheme. If the lights get lost amid all the pattern, strengthen them. During this final step, use a dry-brush technique to keep the soft feel that you've established.

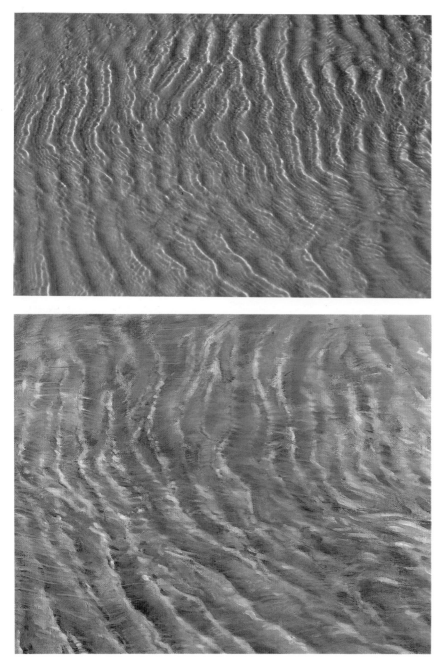

ASSIGNMENT

Try adding an identifiable object to a painting like the one explored in this lesson. It could be a piece of driftwood, a beach ball, or even a pail. Pay attention to perspective—the ripples are seen from above, and whatever you add will have to be viewed from the same angle.

Surf washes slowly over sand, forming intricate, gentle, abstract patterns.

Evoking the Feeling of Soft Surf

PROBLEM

The success of your painting rests on your ability to capture the color, value, pattern, and movement of the water. If one of these elements is off, your painting won't make sense.

SOLUTION

Analyze the anatomy of the water and capture all of its detail in a good, strong drawing. When you start working with color, build it up slowly and gradually.

☐ Draw the scene with care, concentrating on every little detail. Don't rush this stage; there is a real underlying structure to the water and it's vital that you capture it right from the start. When you are happy with what you've done, go back and reinforce your work with thinned color.

Still working with thinned color, brush in the sand on the right and the darkest areas visible through the water. Let the white canvas represent the light foam.

Lay the following colors onto your palette: black, white, permanent green light, cobalt blue, Mars violet, cadmium yellow, yellow ocher, and cadmium red. A pale gray mixed from the black and white will be the backbone of your painting, but throughout it will be tinged with the other hues.

Now start mixing small batches of grayish blues, violets, greens and yellows, then add painting medium to them to form thin glazes. Slowly build up the pattern of the water, working back and forth between the sand and the foam. Use heavier color for the roll of foam at the edge of the wave. Throughout, use short, broken strokes to suggest how the light plays upon the water, and how the water breaks into small areas of color.

Finally, with a small pointed brush, add the stone, the grasses, and the shadows that they cast.

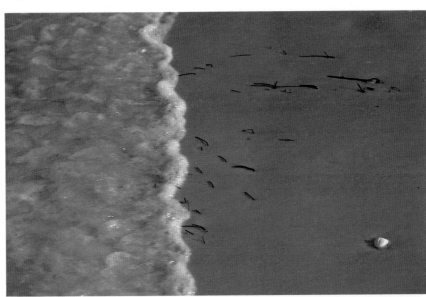

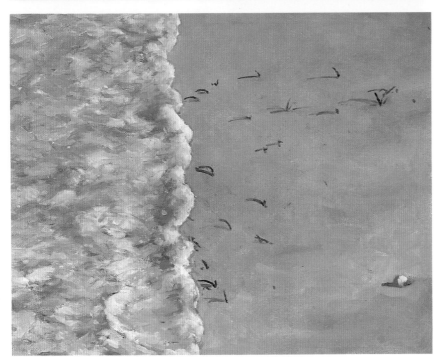

After surf surges over the sand, the water quietly retreats, leaving the sand, a few blades of grass, and a smooth stone behind.

Capturing the Subtle Colors of Wave-washed Rocks

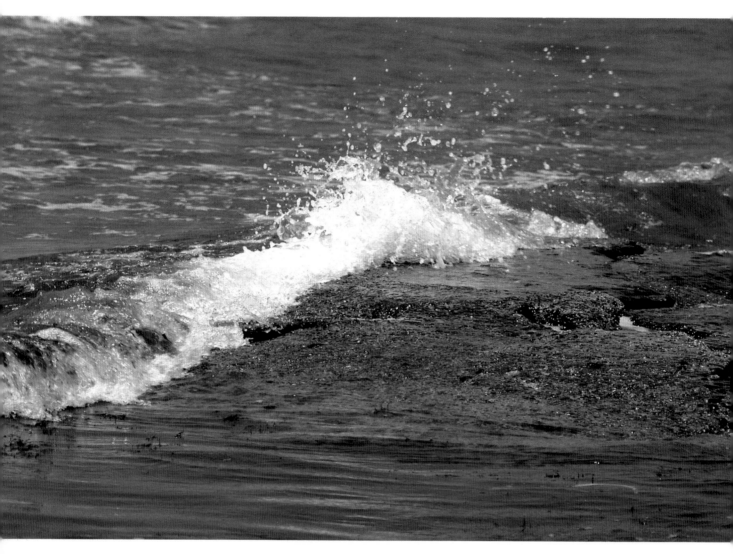

PROBLEM

The breaking wave may be the first thing that springs into view, but it won't be the most difficult element to paint. Capturing the color and brilliance of the rocks is the real challenge here.

SOLUTION

As you establish your color scheme with thinned pigment, loosely brush in the rock formation with rich brownish hues. Later, to capture the warmth of the water that rushes over the rocks, tinge it with Thalo green.

☐ Place the composition on the canvas with charcoal, then redraw it with a small bristle brush and thinned color. Vary the colors that you use to separate the surf, rocks, and water.

Working with thinned color, and from dark to light, block out the color and value schemes. To keep drying time to a minimum, let the white of the canvas represent the pounding surf.

With heavier pigment, start to

A wave crashes toward shore, breaking as it encounters a low-lying rock.

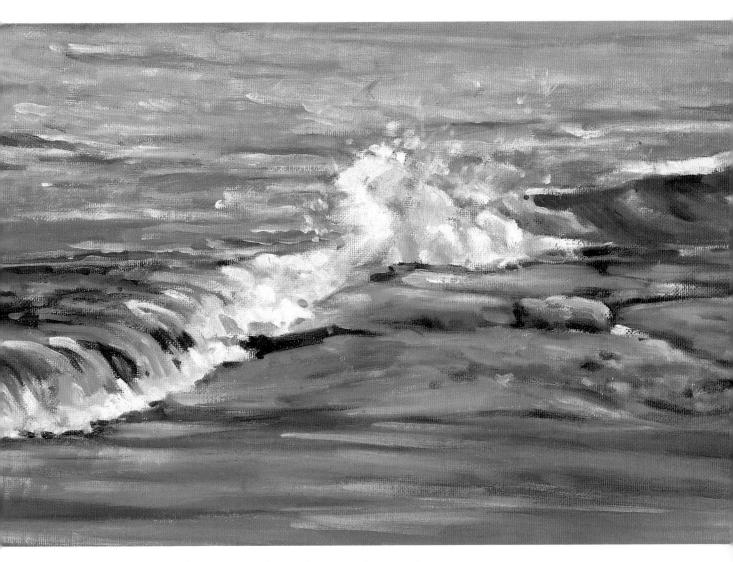

build up the patterns in the water. Use a variety of colors: cerulean blue, cobalt blue, Thalo green, Mars violet, yellow ocher, cadmium red, and black and white. To create a sense of depth, let green dominate the background and violet the foreground; throughout, don't let the water become an uninteresting blue. To render the rocks, use burnt umber, yellow ocher, and touches of cadmium orange. For the water that rushes over them, make Thalo green the principal color.

Finally, turn to the breaking wave. Study it carefully, noting how it has both a light and dark side, then begin to paint it with white, yellow ocher, and a variety of blues and greens.

Finish the painting by adding any necessary accents to the wave and the rocks.

Indicating Bold and Subtle Elements Simultaneously

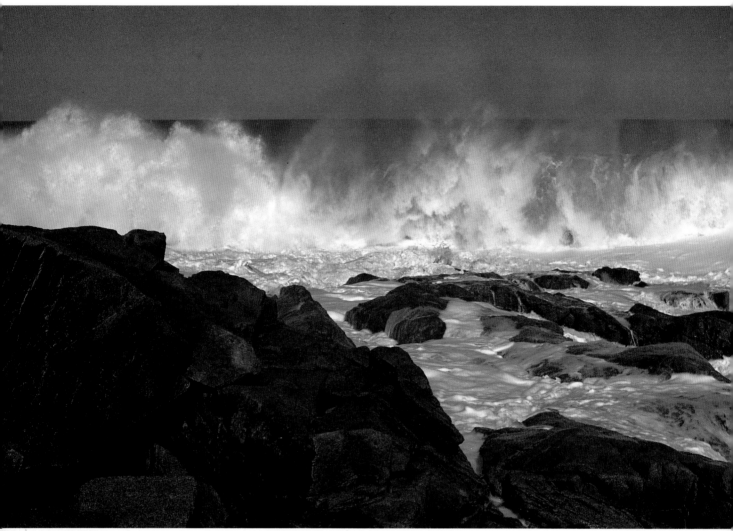

Photograph by Ferdinand F

PROBLEM
Massive, dramatic rocks dominate the foreground; behind them, soft, misty, wind-blown surf shoots upward. Both elements count and have to be captured.

SOLUTION
Emphasize the difference between the two areas. Make the rocks even bolder than they actually are and the surf softer and lighter than it is in reality.

A curtain of water explodes as waves pound against dark, dramatic rocks.

STEP ONE

In your preliminary charcoal
sketch, carefully indicate the con-
tours of every rock and the sil-
houette of the surf. Next, go back
over the lines of your drawing
with thinned color. Here raw um-
ber is used for the rocks and
cobalt blue for the water.

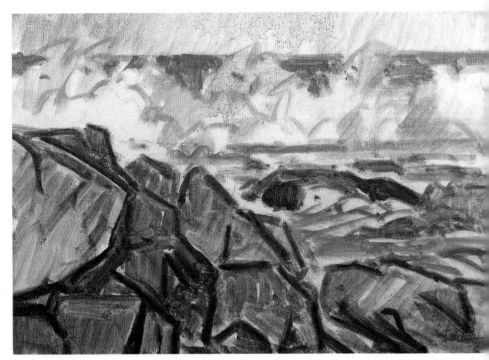

STEP TWO

Working with all the browns on
your palette, and touches of
yellow ocher as well, start to
paint the rocks with thinned color.
By using different shades of
brown, you'll break the rocks
apart from one another and more
clearly indicate their overall struc-
ture. Next, sweep washes of dark
and middle-value cobalt blue onto
the canvas to represent the water
and the sky.

STEP THREE

Switch to heavier opaque color
and begin to search for the exact
colors and values that you want in
the final painting. Continue using
a wide range of colors for the
rocks—even touches of blue—and
render them with strong, asser-
tive brushstrokes. Paint the sky
with cerulean blue, cobalt blue,
and, near the horizon, a touch of
alizarin crimson. When the sky is
dry, scumble the surf up over it,
then add the water in the fore-
ground that eddies around the
rocks.

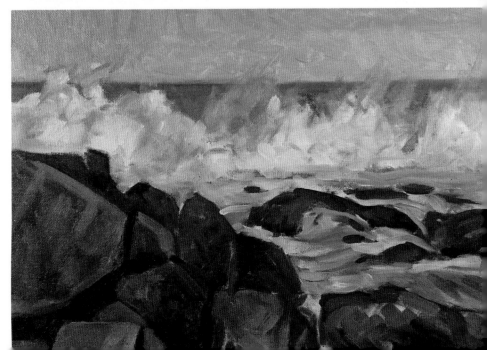

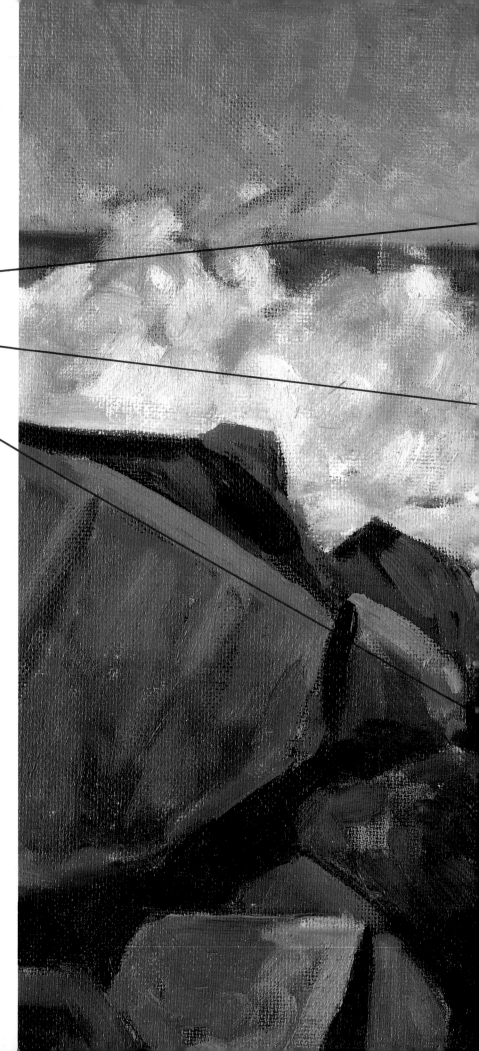

FINISHED PAINTING

If they are to stand out clearly against the water, the rocks have to have sharp, clean edges. Spend a few minutes refining them, then turn to the surf. To make it softer and subtler, try subduing it with pale hues. Here it is rendered with mixtures of white and yellow ocher, white and Thalo green, white and cobalt blue, and white and alizarin crimson.

A streak of alizarin crimson separates the sky from the water, pulling attention back into the composition, away from the rocks.

After the water in the background has dried, the pounding surf is scumbled up over it. Later it is reinforced with thicker pigment.

The rocks in the foreground are warmer and lighter than those in the middle ground. All of them are painted with a wide variety of browns, plus yellow ocher, cadmium orange, and cobalt blue.

ASSIGNMENT

Capturing the power and drama of waves is one of the greatest challenges facing the landscape artist. Waves are in a constant state of flux, which makes them difficult to depict.

The easiest way to become adept at painting them is to sketch them as often as possible. On a day when the surf is strong, bring newsprint, charcoal, and pencils to the beach. With your eyes fixed on the water, loosely lay down the sweeping power of the waves. As you draw, use your entire arm—don't get caught up in small details.

First draw the low swells in the distance. Next, sketch the waves as they crest closer to the shore, following the way they rise then begin to topple over. As they begin to break, record how they turn over and start to explode in spray. Finally, sketch the waves as they crash toward the shore. When you are acquainted with the dynamics of the surf, you'll be delighted at the difference this knowledge brings to your seascapes.

76

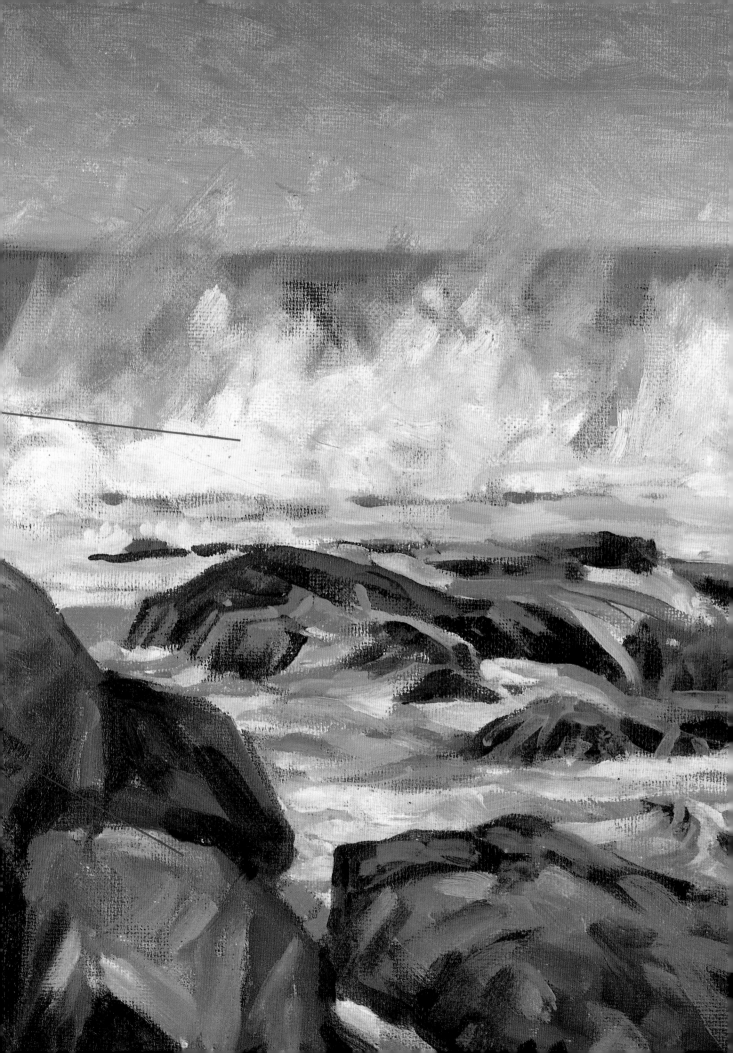

Dramatizing Heavy Surf

PROBLEM
Like most exciting seascapes, this one contains an almost overwhelming amount of visual information. How can you sort it all out, and emphasize what matters most?

SOLUTION
Let the dark wall of water that rises on the left act as a focus for your painting. Make it dark, clean, and sharp, and the rest of the composition can revolve around it.

☐ If you're excited by the motion of the scene and confident about your drawing skills, try working from the very start with thinned color—it will help you work loosely and freely and with as much energy as the scene calls for. Or, if it will make you feel like you have a firmer starting point, sketch the water with charcoal, then go over the lines of your drawing with a turp wash.

After your preliminary work is completed, develop the scene with thinned color; let the white canvas stand for the brightest, lightest whites. Let the canvas dry, then look at what you've done. If you've lost any of your initial drawing, or if you feel that you need more definition before you proceed, get it down now before you continue painting.

Since drama is what you are after, don't weaken your colors with painting medium. Use the pigment straight from the tube as you begin to adjust colors and values. Start with the darks. Here the dramatic wave on the left is painted with Thalo green and alizarin crimson.

For the rock in the foreground, use burnt umber and Thalo blue for the darks, and burnt sienna and cadmium orange for the lights. The sky is painted with cobalt blue, blended with cerulean blue closer to the horizon.

To capture the brooding quality of the water, gray down your color with ivory black. Mix it with Thalo green, cobalt blue, and cadmium red, and add touches of burnt umber to the foam.

Now sharpen your image. Get the edge of the dark wave down as crisply as possible, and strengthen the silhouette of the rock in the foreground. Finally, if your painting seems too dark overall, go back and make the pounding surf brighter and lighter.

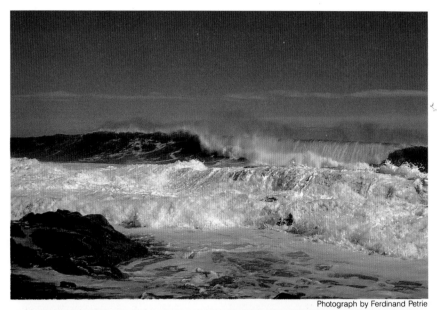

Photograph by Ferdinand Petrie

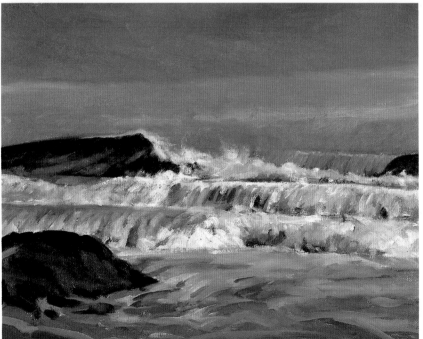

In the distance, dramatic waves rise and fall; closer to shore, calmer waters pulse toward the land.

Working with Complicated Patterns

PROBLEM

The rocks stand dark and imposing against the blue of the water and sky and the white of the surf. To make matters still more complicated, the whole composition is filled with elaborate pattern.

SOLUTION

Don't let the water or the sky become too light—they have to be dark to balance the power of the rock. More important, use the patterns in the foreground to lead the viewer's eye into the picture.

☐ Sketch the scene with charcoal, then simplify your drawing with a bristle brush and thinned color. During this stage, pay special attention to the patterns formed by the moving water, and to the masses of rocks.

Continue working with thinned color as you establish the dark mass of rocks in the foreground, then lay in the sky and the darks of the water. The sky's the easiest area in this composition; turn to it now, using opaque pigment. Try to finish it rapidly, in one session, using a wet-in-wet approach.

The sky done, build up the patterns that lie in the rocks. Use crisp, clean strokes to suggest their rough planes. Force the contrasts that lie in the rocks! They're what give this seascape power.

Now, at last, turn to the water. First lay in the darks, then drag white through the darker hues to establish the brilliant foam. To render the waves that crest and foam in the background, use a drybrush approach, pulling the white pigment up over the sky.

As a final touch, go back to the rocks and clarify their contours. They have to be clean, crisp, and sharp, or they won't stand out against the blues of the water.

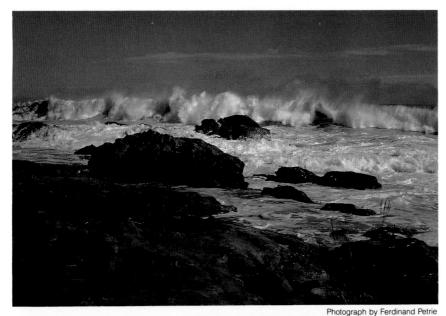

Photograph by Ferdinand Petrie

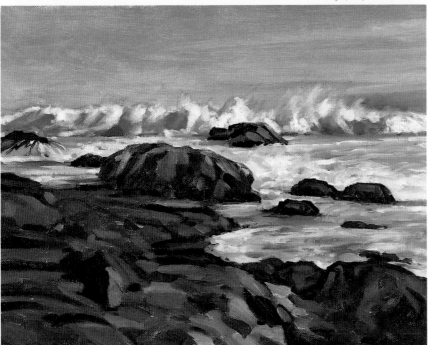

Water slams against the rocks and sand, then eddies slowly toward the shore.

ASSIGNMENT

To better understand the anatomy of crashing waves, photograph the same seascape in rapid succession—take at least 24 exposures. Capture how one wave breaks and rolls into the shore as another starts to build. When your pictures are developed, study them in sequence and you'll learn how the waves build up, crest, crash, and then, in the distance, begin to build up again.

Catching Flickering Highlights

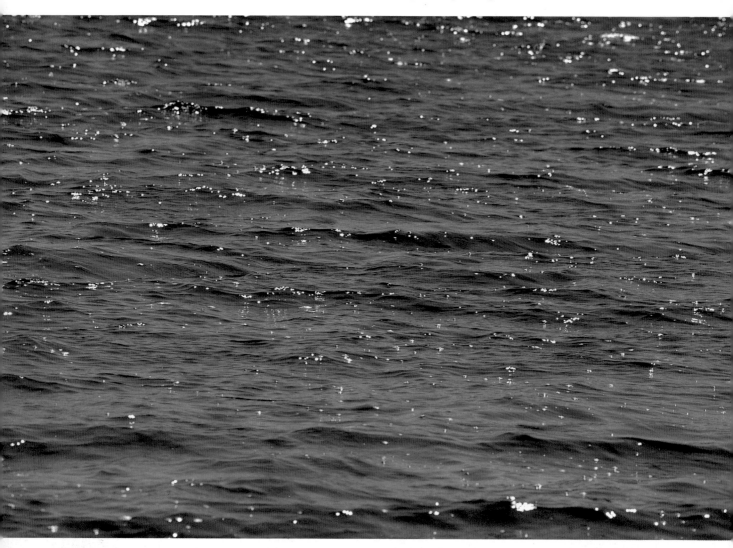

PROBLEM

There's nothing here to disturb the feel of water—that's all you see. But moving in on water alone has its own challenges. Making your painting powerful—and believable—depends upon your ability to capture the overall pattern of the scene and all the nuances that it holds.

SOLUTION

At first, concentrate on the dark and light patterns that lie in the water. Then, when they are fully established, lay in the flickering highlights.

As wind rushes over the water, tiny crests form, catching flickers of brilliant sun.

STEP ONE
Prepare your palette with Thalo blue and cobalt blue, as well as Thalo green and alizarin crimson, then right away, start laying in broad, sweeping strokes of color, using a large brush and thinned pigment. From the beginning, keep a sharp eye on values as you lay in the general pattern of the ripples that move across the lake. At this stage, think of the scene as an abstract composition.

STEP TWO
Now work back over the thin underpainting with thicker color. To make the water seem as dark and intense as it really is, use short horizontal strokes; you'll find that they add mass to what could become loose and flimsy. To make the foreground spring forward, lay it in with larger strokes and darker hues. Most important, don't try to follow your subject too literally—go after its spirit instead.

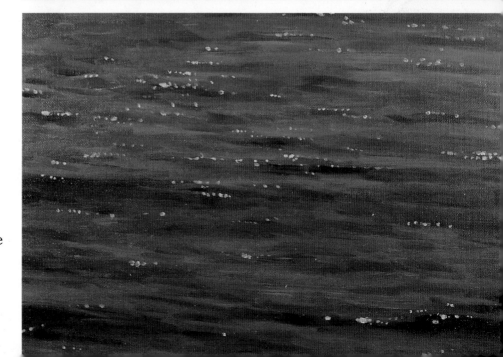

STEP THREE
Once you have built up the pattern of the waves, turn to the spots of color that suggest the highlights that move over the water. To render them, use white, yellow ocher, and a touch of Thalo blue and raw umber. Work over the entire canvas, and don't let the pattern become too regular. To create a realistic sense of depth, make the highlights a little larger in the foreground.

FINISHED PAINTING

Once you've gotten down the basic pattern of the highlights, move away from your canvas for a while. Study it at your leisure, looking for spots that seem a little off and for areas where the pattern of the highlights seems too regular. At this point, let the needs of your painting take over—don't try to copy the scene slavishly. Figure out what it needs, then sharpen your composition.

The water's deepness, movement, and transparency are created by applying layers of ever-thicker paint, first in broad, sweeping strokes, then in large, clear brushstrokes, and last with quick dabs for the highlights. The trick is to allow the previous layers to show through.

The dark blues in the bottom of the canvas are stronger and deeper, and the white highlights crisper, brighter, and bigger. This establishes a definite foreground, giving an almost abstract picture a feeling of perspective.

82

Moving in Close on Detail

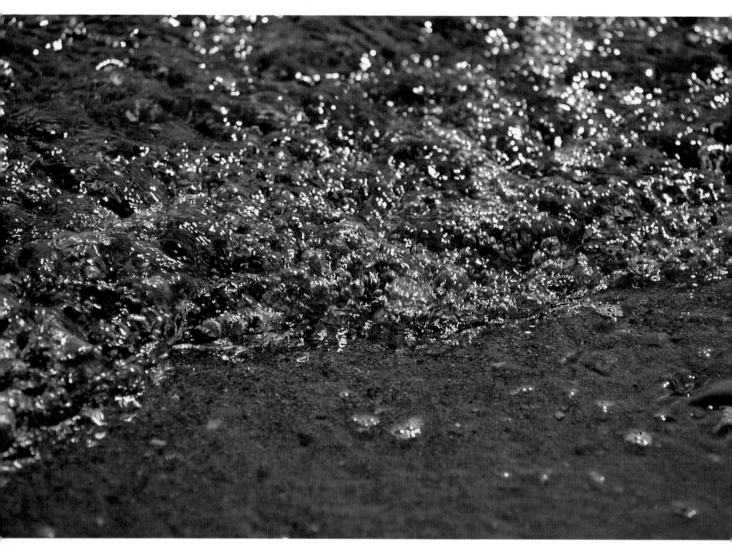

PROBLEM
There's a complex mass of visual information here, but there's nothing much to hold it together. Organizing what you see and making it seem real is the key to creating a dynamic painting.

SOLUTION
In the early stages of your painting, concentrate on abstract patterns. Once they've been established and the composition has begun to develop, start adding detail.

☐ When a scene is as ephemeral as this one, don't bother with a charcoal sketch. Instead, lay in an overall wash of thinned color, here made up of raw umber and white. As you paint, vary your values; keep the glistening water at the top lighter than the sandy beach below. Now let your canvas dry, then go back over it with a small bristle brush and thinned color, getting down the major design elements that you see. Concentrate on the edge of the rolling water and on the patterns that the surging water creates.

Begin working with thicker pigment. Using a short bristle brush, build up the lights and darks of

Rushing water rises toward the shore, then retreats, forming a rich mosaic of color and light.

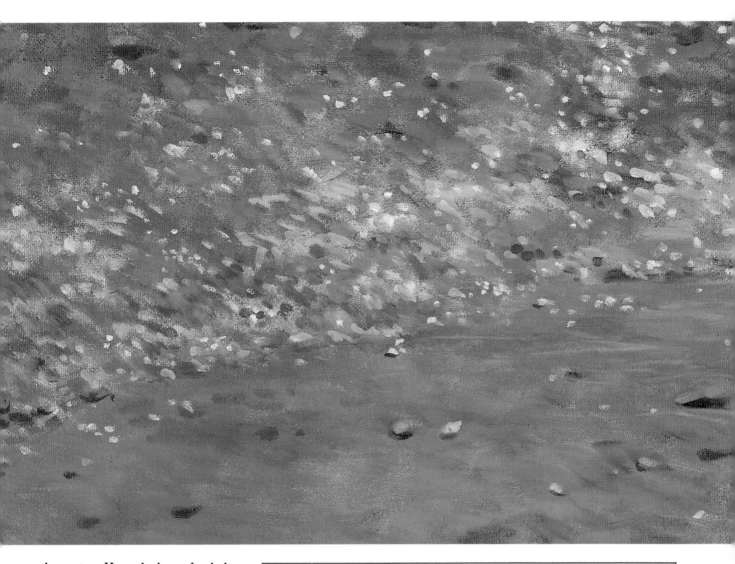

the water. Here dashes of cobalt blue lie interspersed with touches of raw umber, white, Thalo green, and yellow ocher. When you turn to the shore, use broader strokes, and add a little Mars violet to your palette. Finish the shore in one step—when it's done, you can go back and concentrate on the water.

Now continue building up the patterns in the water, layering one stroke over another. All the while, keep an eye on values and color! Make the darks dark, the lights light, and throughout the painting, don't let your colors become flat.

ASSIGNMENT

If landscape painting is what you love, what's the point of painting these intricate details that close in on just a few feet—or inches—of water or ice?

These subjects can give you a new freedom when you go back to painting rushing surf or the beauty of a lake at sunset.

After you've mastered how to depict water lapping slowly onto a beach, you'll find that all your seascapes have more authority. Even when you are painting a group of children at play on a beach, you'll be able to get the background down correctly. When you approach a confusing winter scene, filled with snow, ice, and frost-covered vegetation, you'll feel more at home than before, too, if you've closed in on just a few blades of snow-covered grass and worked with them closely.

Rendering a Stark Silhouette at Sunset

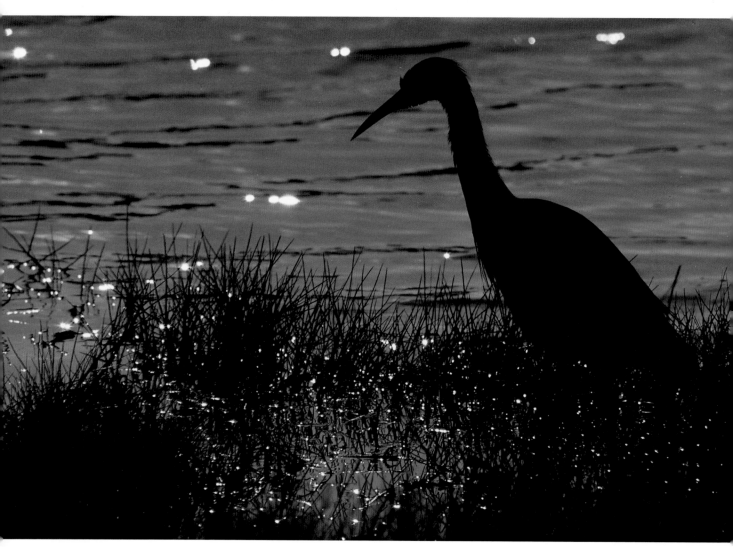

PROBLEM
The contrast between the bird and grasses and the water is so strong that you could easily lose what matters most here—the effect created by the shimmering water.

SOLUTION
Keep the dark elements as simple as possible, and save them for the very end. Concentrate, instead, on the water.

☐ Place the composition on your canvas with a simple charcoal sketch, then go back over it with thinned color. Don't just draw the bird and grasses—try to capture the patterns in the water, too.

Switching to opaque pigment, work wet-in-wet and begin to build up the water. Pay careful attention to its color. If you study it closely, you'll find that it's made up largely of green, not blue. Try using Thalo green and cobalt blue, plus white and alizarin crim-

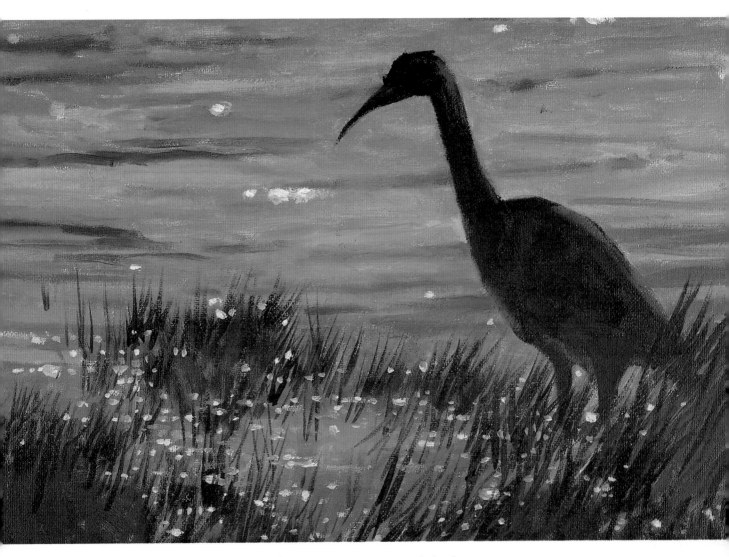

son to render it. And keep your values dark; they have to be to make the highlights that move across the water stand out. During this stage, paint right over the grasses in the foreground. You'll go back to them a little later.

When you are happy with the water, turn to the bird. Keep it simple, adding just a little modeling so that it doesn't seem pasted to the canvas. For the grasses, add plenty of painting medium to your color to keep it fluid, and lay in your strokes with a long-haired rigger brush.

Finish the painting by adding the spots of light that lie across the water. Don't use pure white! Keep some color in these highlights, and they'll blend in easily with the rest of your painting. Finally, make the highlights in the center of the composition brighter and lighter than those closer to the edge.

Painting Ice

PROBLEM

How can you render ice? After all, it's transparent, and at first doesn't seem to give you anything tangible to work with.

SOLUTION

When you begin your painting, forget about the ice. Think, instead, about the dark water that's visible beneath it and around the stone.

☐ Sketch the composition with soft vine charcoal, then redraw it with thinned color, paying special attention to the darks and lights of the underlying water. For the time being, let the white canvas represent the white edge of the ice.

Now, working with heavier color, develop the darks that run throughout the scene. Use a wet-in-wet approach, brushing small bits of color into each other. Don't let any one area dominate. When you move closer to the broken ice that surrounds the stone, use the same hues, but lay in your color with smoother strokes. Keep the stone simple—if you pay attention to its lights and darks, you'll capture its mass and its round shape.

Now step back from your canvas. If your values are too light, make them darker and richer, but keep the colors mottled and subtle. That done, add the light film that rims the broken ice, keeping it crisp and light.

At the very end, go back and add the dark accents that you need. In particular, surround the brightest lights with a thin ridge of dark color to make the lights really stand out against the darker ice.

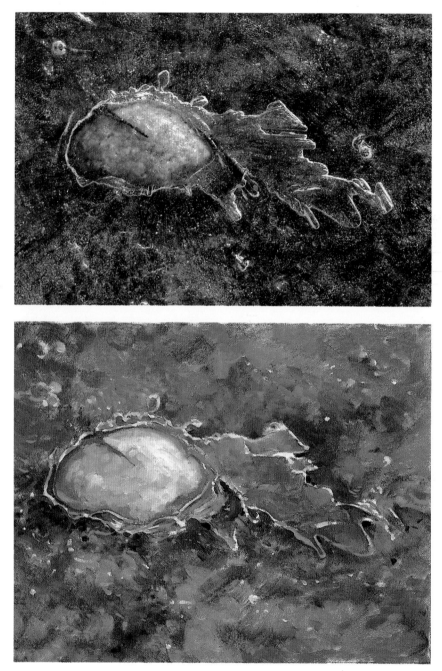

A rock lies in the middle of a frozen stream, with the ice surrounding it forming a rich, glistening mosaic of color and light.

DETAIL
Mostly gray in nature, in this painting the ice is transformed into a web of interweaving colors. A light gray hue, mixed from black and white, is toned throughout with brown, violet, and blue. Because the colors are based on gray, and laid in wet-in-wet, with overlapping strokes, the end result is a subtle mix of closely related hues and values.

ASSIGNMENT
Don't get locked into any one particular way of viewing a scene. If your bent is toward the abstract, try working more realistically. On the other hand, if you are always concerned with capturing the particulars of a composition, try instead to establish its underlying structure. Working with an approach that's alien to you can give you a deeper understanding of your own style—why you like it and why it works for you. More important, you may find that working in a controlled fashion gives structure to your abstract works, or that working loosely enlivens your realistic paintings.

Capturing the Feeling of Opaque Ice

PROBLEM

What seems simple at first can actually be very difficult to render. Here you have to capture the feel of the ice and the fact that the leaf lies trapped in it.

SOLUTION

Lay in the ice gradually, scrubbing thin layers of pigment onto the canvas, then go back and paint the leaf as realistically as possible.

An oak leaf and two blades of grass break through a thin layer of opaque ice.

90

STEP ONE

With a sharpened charcoal pencil, carefully draw the leaf; keep its lines crisp and clean, then redraw it with a small pointed brush and thinned color. Don't just try to capture the silhouette of the leaf; instead, add some of its texture as well. The thin washes of color that you'll be using later will let these nuances shine through.

STEP TWO

Begin to build up the background working with a bristle brush and very little painting medium. Scrub the color onto the canvas, and make each stroke blend smoothly into those that surround it. To keep the ice interesting, mix small batches of color repeatedly, then lay them down. Don't let any sharp edges appear; the soft effect you're after is especially important where the leaf breaks through the ice.

STEP THREE

Develop the color and the texture of the leaf, using mixtures of yellow ocher, raw sienna, and Mars violet. Small, stippled strokes suggest the crinkly texture of the dry leaf. To render the thin, delicate veins and the icy rings that surround the leaf, use a rigger brush. Now strike in the thin blades of grass, and make any necessary adjustments in the color and value of the ice.

FINISHED PAINTING

Fine tune your painting. Bring out the lightest portions of the leaf with yellow ocher, then lay in the sparkling highlights that flicker across the ice. As a final touch, strengthen the dark shadow beneath the leaf.

Subtle shifts in color run through the ice and help suggest its opacity. The pigment is scrubbed onto the canvas with a bristle brush.

The sparkle of ice that rims the leaf is rendered with yellow ocher and white. The two hues are loosely mixed together, so flecks of gold stand out clearly.

ASSIGNMENT

If abstract paintings fascinate you, yet you shy away from executing them yourself, try using something real—ice or water—as a point of departure. Choose a subject made up of complex patterns: ice forming around a submerged leaf or rock, wavelets rippling over tightly packed sand, or an icicle hanging from a tree.

As you sketch the scene, don't look at the canvas; aim at coordinating your hand and your eye. When you begin to lay in thin turp washes, continue to refer to the canvas as little as possible. Then, as you build up thicker color, work loosely, concentrating on overall pattern.

When it comes time to add finishing touches to your work, you may find that what you've done doesn't really resemble your subject—just the effect you wanted! Instead of pulling the painting into focus, try emphasizing the abstract shapes that appeal to you the most.

Picking Out the Patterns Formed by Brilliant Highlights

PROBLEM

What's unusual about this subject is the crystal-clear ice that encases the leaf. Made up of minute highlights, shadows, and fissures, it will be extremely difficult to paint.

SOLUTION

To capture all the detail and pattern that you see, execute a very careful preliminary sketch using a hard charcoal pencil.

☐ Using a razor-sharp charcoal pencil, sketch the composition carefully, then reestablish the lines of your drawing with thinned color. Now quickly sweep a thin wash of color onto the canvas to suggest the warm tones of the leaf and stem.

Working with a large bristle brush and opaque pigment, start to build up the background. To capture its soft, unfocused nature, use broad, scrubbing strokes, and several shades of dark green; the green has to be very dark if the bright ice is to stand out against it.

Now turn to the leaf and stem. Here they are rendered with yellow ocher, cadmium red, cadmium orange, burnt sienna, and just a touch of white.

Next, carefully pull out details such as the veins with a small sable brush, then paint the darks and lights of the ice. Keep your eye on the patterns they form, and don't let your brushstrokes become too regular.

Let the canvas dry, then as a final touch, mix the warm hues you used to render the leaf together with a goodly amount of painting medium, and carefully apply the glaze to the leaf and stem. This transparent layer of color will suggest the look of the ice coating the leaf without obscuring the structure of the leaf. If your first application doesn't work, quickly wipe it off with a soft rag, then reapply it.

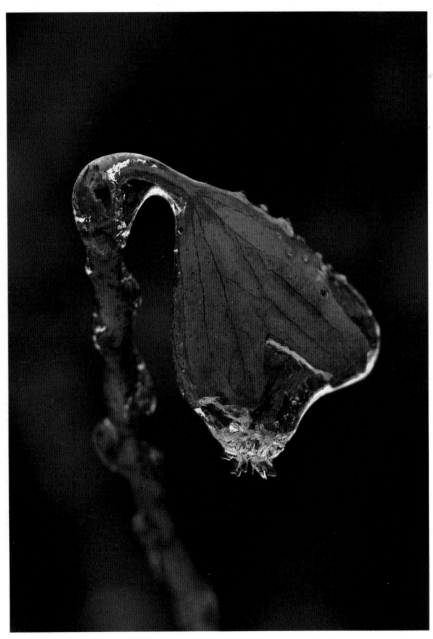

Thick brilliant ice clings to a lone oak leaf.

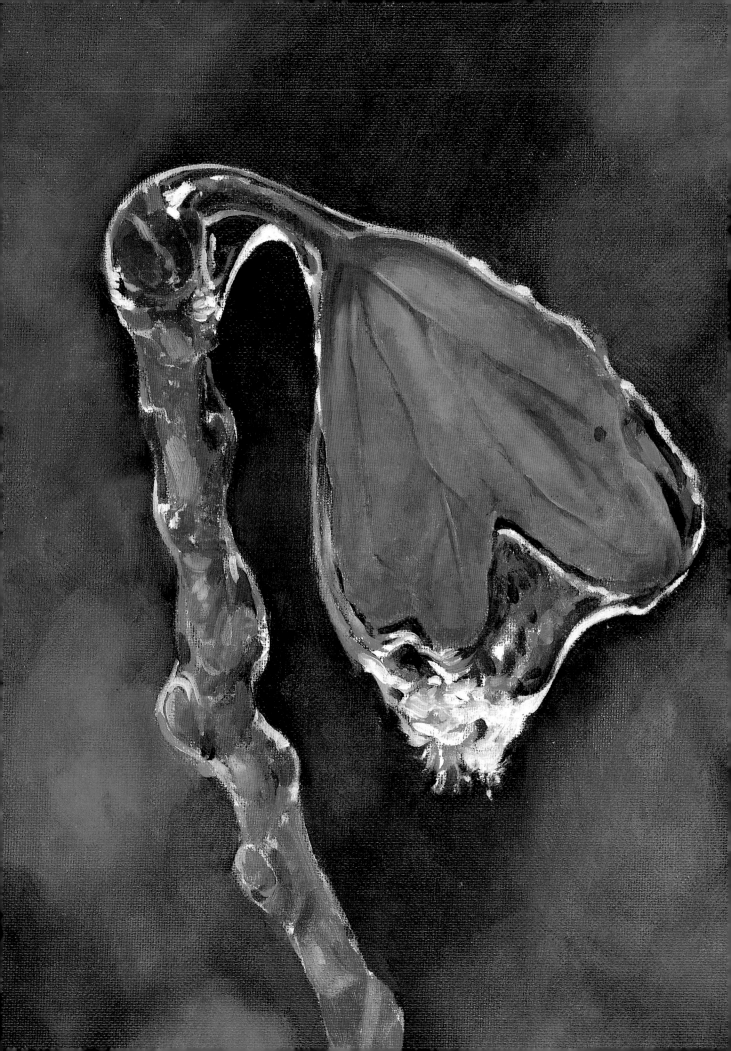

Exploring the Structure of Ice Crystals

PROBLEM

It's just what makes this composition so stunning that will make it so difficult to capture in paint: The structure of the ice crystals is incredibly complex.

SOLUTION

Work back and forth between the dark background and the light crystals, constantly keeping your eye on the pattern the crystals form.

☐ A thorough drawing will be the backbone of your painting, so take your time getting down everything you see with a charcoal pencil. Fix the drawing, then go back over it with thinned color. Continue working with thinned color as you establish the dark background and the leaf.

Switching to heavier color, further develop the background, then with short, light strokes, add the bits of blue that lie within the frosty crystals. Using yellow ocher and burnt sienna, render the leaf, paying special attention to its shape. Finally, lay in the crystals with a rich creamy mixture of yellow ocher and white.

With a small, pointed brush, define the edges of the frost, working back and forth between the crystals and the background. When you are satisfied with the structure of the ice, gently dab touches of medium-value blue onto the canvas to suggest the ice crystals that spread out from those in the center of the composition.

Feathery white ice crystals spread outward from a delicate golden-brown leaf.

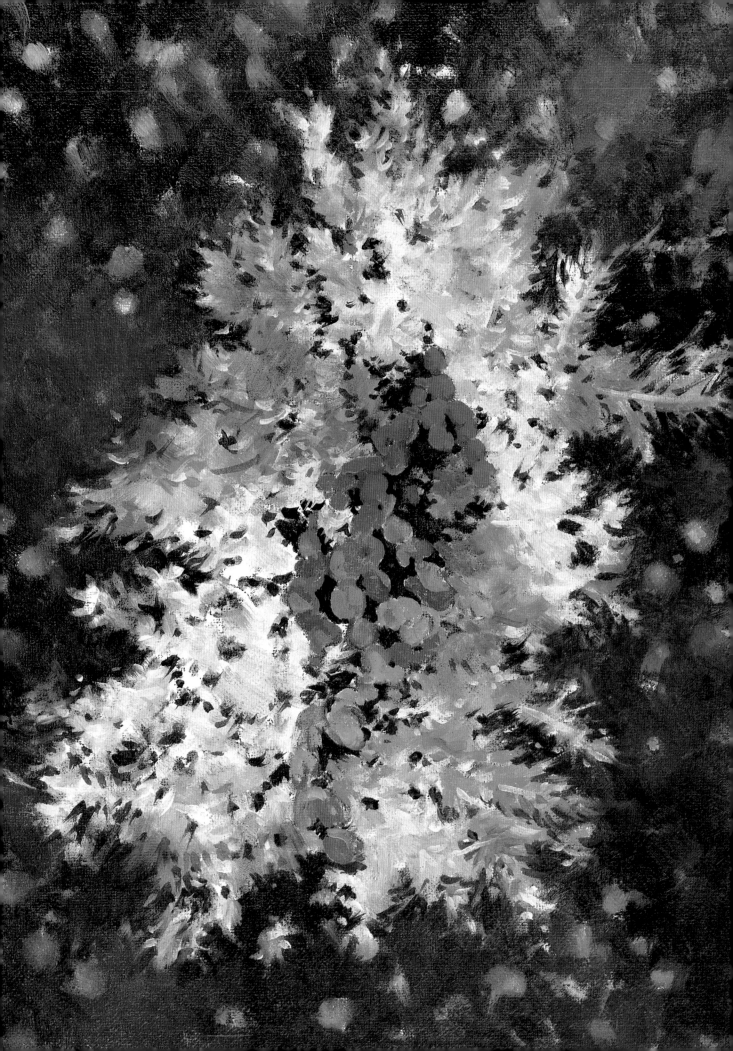

Handling Diverse Textures

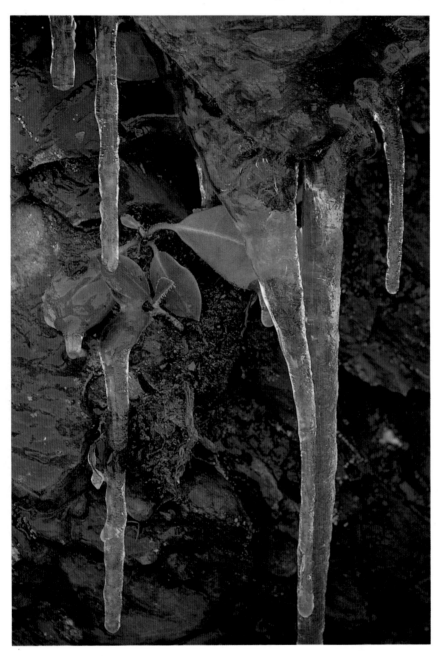

PROBLEM

Many elements fight for attention here—the thick icicles, the rough rocks, and the smooth leaves. If they are all given equal attention, your painting will probably be confusing.

SOLUTION

Simplify the rocks as much as possible to set off the glistening ice.

STEP ONE

In a careful charcoal drawing, record the shapes that crowd this composition. Don't just follow the outlines of the icicles and leaves. Instead, try to capture the little details that suggest all the different textures that you see.

Strong, thick icicles hang from a rough sheet of rock and encase smooth mountain laurel leaves.

STEP TWO

With thinned cobalt blue, reinforce the lines of your drawing, then start to establish your overall color scheme. Continue using thinned color as you brush in the green of the leaves, the blues that rush through the icicles, and the browns, blues, and grays that make up the rocks. During this stage, start to simplify the background, breaking the rocks into large abstract areas of color.

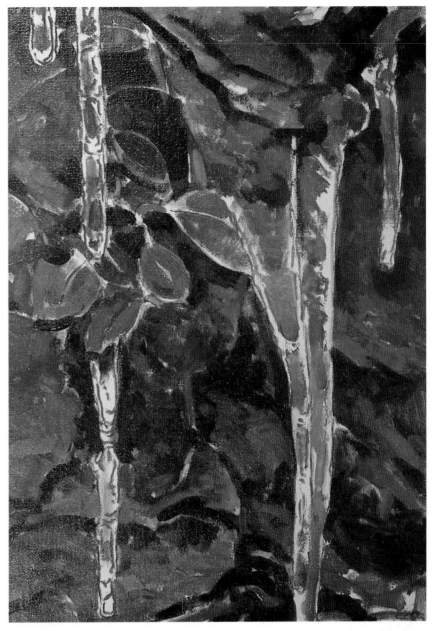

STEP THREE

The cool, dark rocks spring into focus as you begin to build them up with opaque pigment. Keep their shapes strong, but simple, and their values good and dark. Now using the same hues, paint the dark shadowy portions of the icicles. Remember—you are actually looking through the ice, and not at the ice itself. Finally, paint the smooth green leaves.

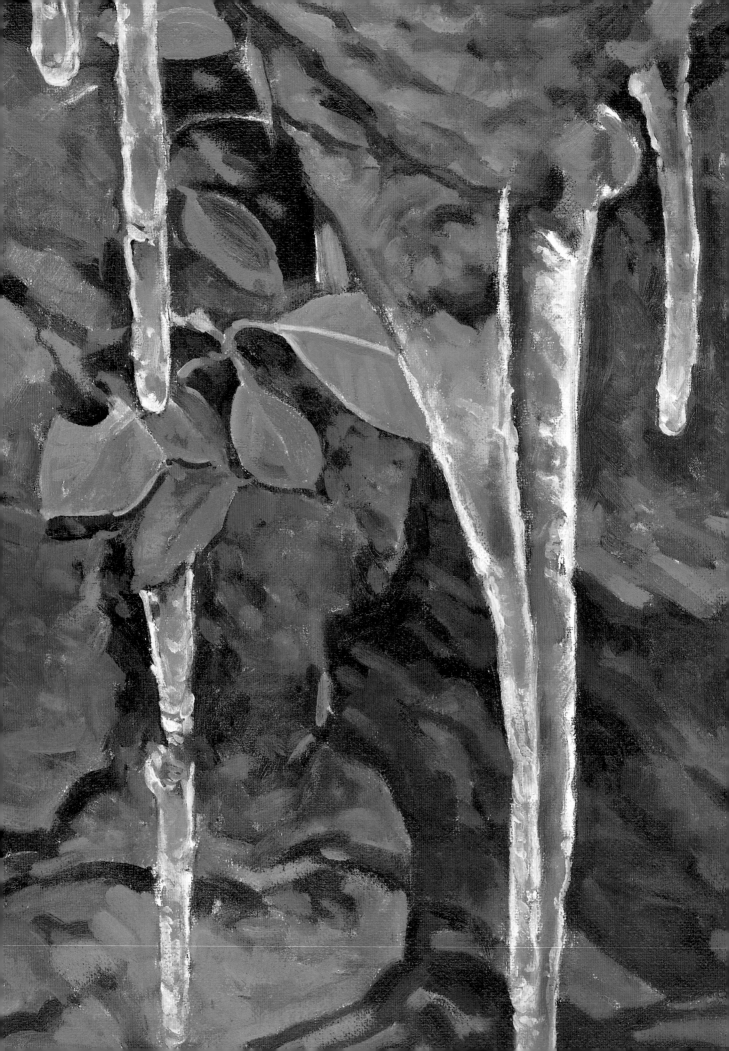

FINISHED PAINTING

In the final stages of your painting, concentrate on the icicles. Crisp, clean touches of white bring up the highlights that animate the ice, while softer strokes of dull bluish-gray and brown further develop the shadows. Once you are satisfied with the icicles, scan the rest of your painting, looking for areas that need definition. Carefully render the leaf stems, and any other details that you may have overlooked.

DETAIL

Many colors come into play in this painting, yet they work easily together, in part because they are closely related in value and in part because they are laid in with large, loose strokes. The dark hues that make up the rocks set the stage for the brilliant highlights of the icicles.

DETAIL

Crisp strokes of pure white define the edges of the icicles and set them off from the dark background. Note the number of colors used to render the icicles—white, ocher, browns, blues, and even touches of green where a leaf lies hidden behind a column of frozen water.

101

Working with a Limited Palette

PROBLEM

When only a handful of colors make up a subject, a painting can easily become static and dull.

SOLUTION

Let contrasting values animate your painting. Start out by staining the canvas with a medium-value blue, then concentrate on the strong lights and darks.

□ Capture the flowerlike configuration of the moss and ice in a careful charcoal drawing, then spray the canvas with a fixative. Now mix a thin wash of cobalt blue and apply it to the entire canvas. While it's still wet, take a rag and wipe out the brightest lights. Finally, strengthen the dark lines of your drawing with thinned cobalt blue and black.

Working back over your drawing, begin to paint the darks of the background with opaque pigment. Before you begin, stop and study the icy formations. Note that they resemble flowers and keep their structure in mind as you paint.

First lay in the dark blues, then the green leaf and the brown branch. The darks down, gradually build up the medium values, then turn to the lights. Lay in the highlights, then go back and reinforce their edges by strengthening the darks that surround them. At the very end, study the overall painting, looking for areas that seem too light, too dark, or too weakly defined.

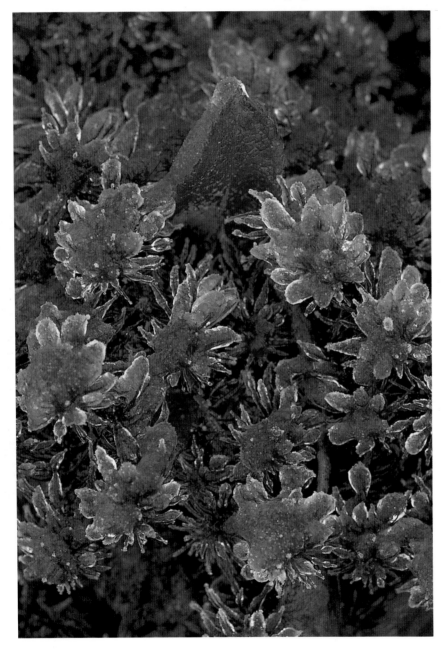

ASSIGNMENT
Find subjects like the one explored in this lesson using a camera. Looking through a camera's viewfinder is an easy way to isolate interesting details that you might otherwise miss. Or try this: Cut rectangular viewfinders out of heavy cardboard and use them to frame interesting details.

Crystals of ice grow in flowerlike formations, mimicking the moss that lies beneath them.

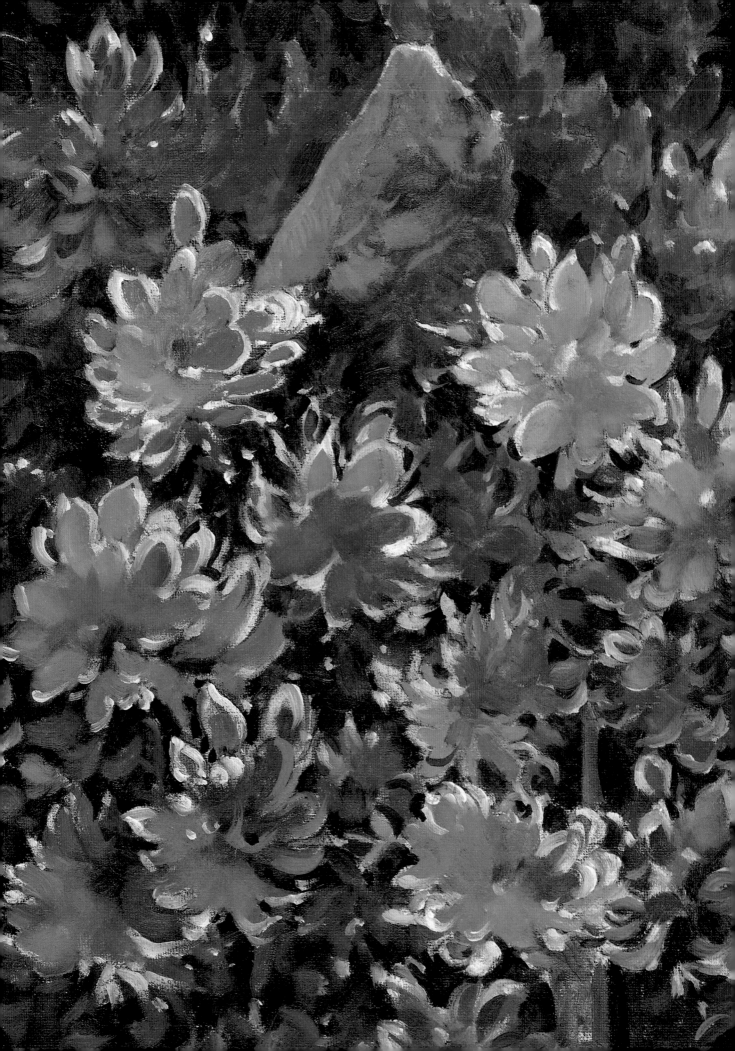

Depicting a Delicate Fringe of Frost

PROBLEM
Strong reds and greens vie for attention with delicate frost. Somehow you have to balance these dramatic and subtle elements.

SOLUTION
Keep the background and the leaves dark enough, and the frost will spring into focus.

☐ Sketch the scene with a charcoal pencil, fix the drawing, then reinforce it with thinned color.

Now go to work on the background, using opaque pigment. Don't add any painting medium—you want your colors and values to be intense—and scrub the pigment onto the canvas to create a soft, unfocused feel.

Using smoother strokes, lay in the leaves and the flowers. To keep the red really vivid, add as little white as possible. For the time being, let the white of the canvas represent the frost.

Once the major forms are established, go back over your painting adding details, such as the veins that line the leaves.

Finally, tinge white pigment with alizarin crimson and Thalo blue, then paint the frost with gentle, feathery strokes.

The bell-shaped flowers of a blueberry bush are dusted with minute crystals of ice.

Learning How to Paint Transparent Drops of Water

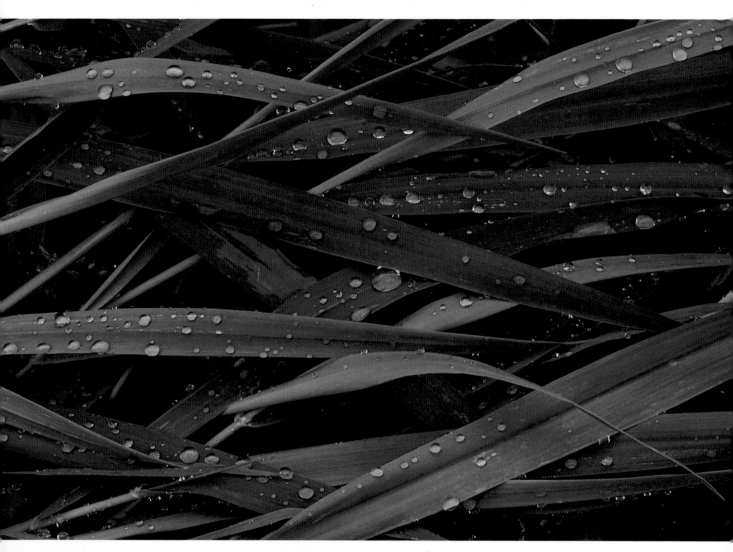

PROBLEM
Two challenges confront you here: the patterns formed by the grasses and the delicate nature of the raindrops. Both must be captured.

SOLUTION
Deal with one problem at a time. First develop the blades of grass, then paint the raindrops right over them.

Raindrops glisten on interwoven blades of rich green grass.

STEP ONE

Precise subjects like this one call for strong drawings, so spend as much time as you need to record the anatomy of the grass. Next, spray your drawing with a fixative, then apply a thin wash of permanent green light to the entire canvas. When the surface is dry, reinforce your drawing with thinned color and a small pointed brush.

STEP TWO

Your pigment has to be fluid when you start to build up the grasses, so add plenty of painting medium to your color before you start. Get the darks down first with a rich blend of Thalo green and alizarin crimson, then turn to the medium values, rendering them with Thalo green and permanent green light. Use long, clean, sweeping strokes, and make sure that the edges of the grass blades stay sharp.

STEP THREE

As you begin to reinforce your underpaintng with opaque pigment, vary your colors as much as possible. Add touches of cobalt blue and yellow ocher to your greens, and even bits of cadmium yellow. Vary temperature, too. Here warm, vibrant passages stand next to cooler areas, creating a sense of depth. When you are totally satisfied with the grass, start to render the raindrops.

FINISHED PAINTING

It's capturing the play of light on the raindrops that will make them convincing. Each drop is made up of a highlight and a shadow. First, using small, circular strokes, lay in dabs of white. While the pigment is still wet, go back and work in tiny bits of pale bluish-green, pulling the darker pigment through the white. As you work, keep your eye on the direction that the light takes.

Warm and cool hues and dark and light values separate the individual blades of grass and add drama to the pattern that they create. Very little suggestion of the painting process is evident in the finished work because the pigment has been thinned with a generous amount of painting medium.

Almost every raindrop is made up of a highlight and a shadow. First, pure white is dabbed onto the canvas, then a pale hue of bluish-green is run through the white to place the shadow.

Choosing a Small Support

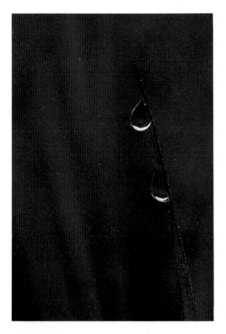

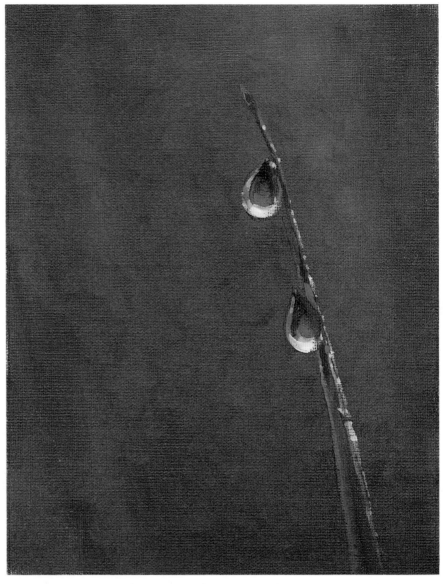

PROBLEM

The success or failure of your painting rests entirely on your ability to paint the dewdrops. They're obviously the focus of the composition.

SOLUTION

Don't make matters even more difficult by working on a grand scale. Instead, choose a small support, one about eight by ten inches.

☐ Because of the simplicity of the composition, try a new approach. Work up the background thoroughly, without any preliminary drawing, then let the canvas dry and add the dewdrops. Mix together a dark, dull shade of green and lay it in all over the canvas with firm strokes. To make it a little more interesting, work touches of yellow ocher into the green. Now let the surface dry.

Using soft vine charcoal, carefully sketch the grass blade and the drops of dew, then go over the lines of your drawing with thinned color. With a small pointed brush, render the grass; remember to pull out the tiny highlights that lie along its edge and to inject the blade itself with as much color as possible. The grass done, turn to the focus of the composition, the dewdrops.

First get the darks down, using the same colors that make up the background. Now add even darker touches of color near the top of each drop and down its side.

Finally, add the bright highlights that shimmer at the base with a mixture of yellow ocher and white, and run a little pale blue around the sides of the drops to separate them from the dark green background.

Two dewdrops hang from a lone blade of grass.

Animating Dark Water

PROBLEM

At first glance, this landscape seems perfectly straightforward. And in a way it is. But if you follow what you see literally, you'll end up with a mass of medium-value green. Surely there's a more exciting way to work out your painting.

SOLUTION

Add as much variety as possible to the greens, darken the foreground, and transform the still green water into an exciting mixture of blues.

A bold white bridge spanning a pond is mirrored in the dark green water that lies below.

STEP ONE

Do a quick charcoal sketch of the scene, then reinforce your drawing with thinned Thalo green. Now sweep in the dark foreground and the tree, and you'll immediately establish a sense of depth.

STEP TWO

Now's the time to set up your color scheme and your value scheme with thinned color. Loosely indicate the dark foliage in the background, then lay in the brilliant green bank on the right. Finally, get down the blue of the water and the pale gold reflection of the bridge.

STEP THREE

By now, the basic framework of your painting is completed. All that remains to be done is to articulate your underpainting with opaque pigment. Just as before, use a broad range of greens to render the foliage. As you paint the water, follow the dark and light patterns that wash over it. Pause from time to time and make any necessary adjustments in color and value. Toward the end, complete the bridge and its reflection.

FINISHED PAINTING

Move away from your painting for an hour or two, then come back and look at it afresh. No doubt you'll find areas that need definition. Here, for example, the water seemed lackluster. By increasing the strength of the darks and adding a few additional lights, the foreground became much stronger. As a final touch, strokes of brilliant burnt sienna were added to the base of the tree to pull that area forward, and the golden-green of the bank on the right was intensified.

Analyzing Light and Dark Values

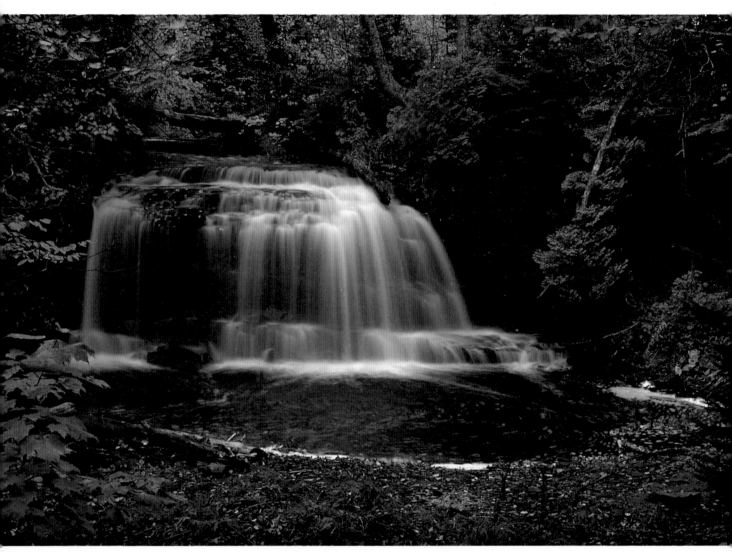

PROBLEM

The frothy white water stands out dramatically against the dark greens and golds that make up this scene. You could easily over-emphasize the whites, and make the water look artificial.

SOLUTION

Analyze how the water actually looks. Note that it forms definite planes; at the top of each rock, the water is brilliant white, but as it falls, it becomes darker and duller.

☐ In your drawing, place all the elements of the composition with vine charcoal.

The drawing done, go over it with thinned color. Continue working with diluted pigment as you start to build up the painting. Make sure your darks are dark enough; at this stage, everything looks dark against the white canvas and you can easily work too lightly.

Here the foliage is rendered

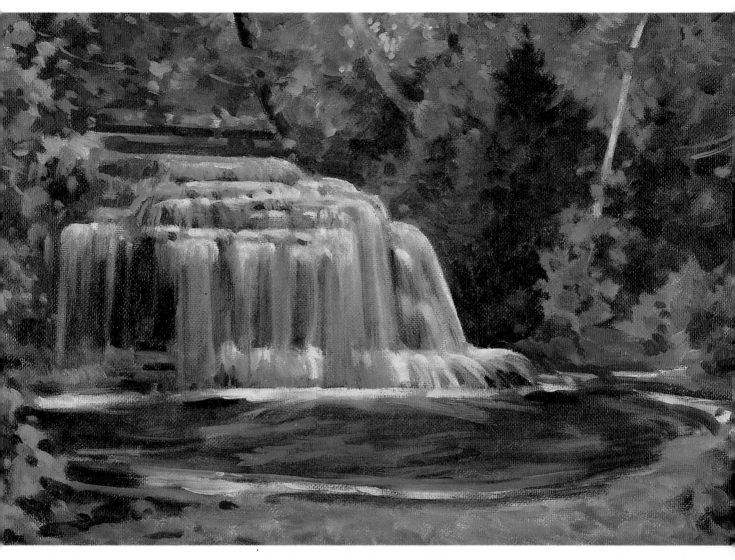

with Thalo green, permanent green light, yellow ocher, cadmium yellow, and cadmium orange. In places, touches of burnt sienna darken the greens. The water is made up of Mars violet, Thalo blue, Thalo green, cobalt blue, alizarin crimson, black, and white.

With heavier color, develop the dark areas around the falls. Use short, choppy strokes as you lay in the foliage, and follow the direction in which it grows. When you turn to the water, lay the paint down with longer, softer strokes. Begin with the dark vertical streaks of color that lie beneath the glistening whites. When they are down, go back and gently lay in the frothy whites.

As a final step, add dashes of Mars violet to the pool of water under the falls, then touches of white to the edges of the pool.

Balancing Many Diverse Elements

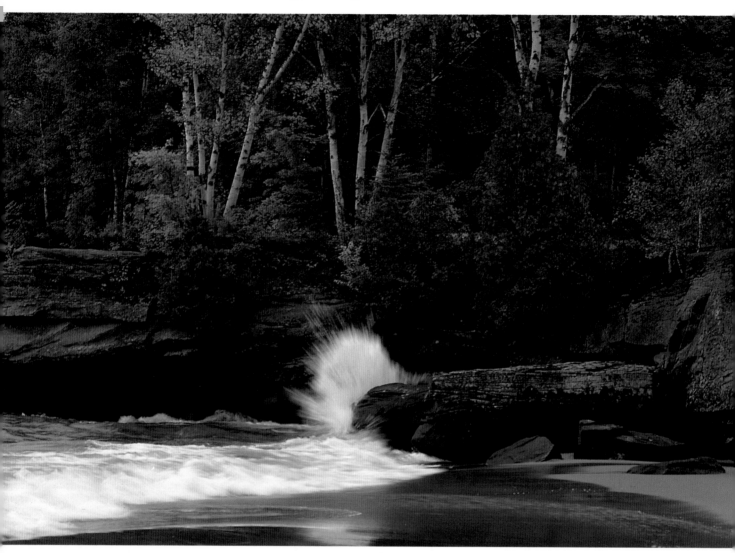

PROBLEM

There's no single problem here, yet this composition will surely test your abilities. It's made up of many diverse elements—the rocky shore, sandy beach, and surf, plus a magnificent autumn landscape.

SOLUTION

Start with a detailed charcoal drawing, then use a traditional dark-to-light approach. Let your brushstrokes help separate the different areas, too.

☐ With soft charcoal, sketch the scene. Work freely, and don't be afraid to use a lot of lines as you feel your way through the composition. Now dust off any loose charcoal and reinforce the sketch with thinned color. Let the surface dry.

With thinned color, start to paint the darkest areas. Make the rocks really dark—since they form the darkest value in the scene, they can help you gauge the rest of your values.

The dark rocks in the center of

In autumn at Lake Superior, water washes toward the shore, exploding as it crashes into a rock.

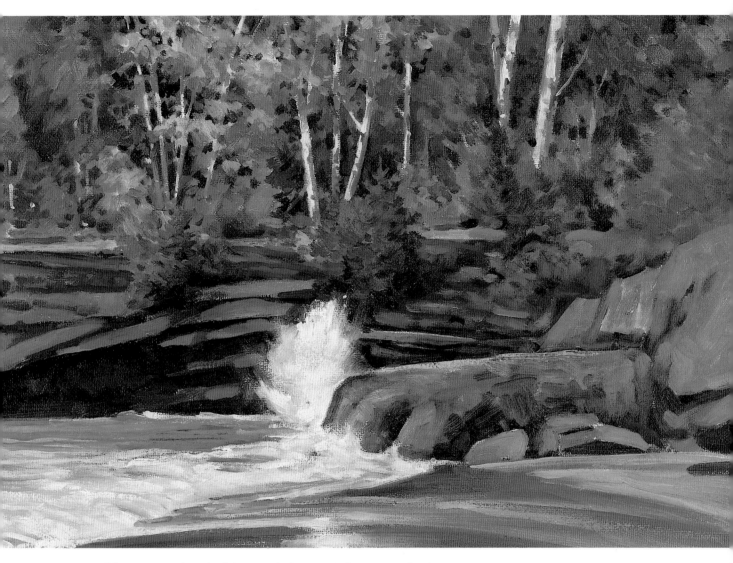

the composition are rendered with Mars violet, raw sienna, and alizarin crimson. Those in the foreground are made up of the same hues mixed with white and black.

Because the trees are built up of many different colors, it's easy to establish their individual shapes. Get them down with thinned color, then start to develop them with thicker pigment and short, choppy strokes. Here they are rendered with Thalo green, yellow ocher, cadmium yellow, cadmium orange, and cadmium red. As you lay in the lighter trees, work back and forth between the dark green foliage in the background and the brighter leaves.

Finally, lay in the sandy shore with broad, sweeping strokes of yellow ocher and burnt sienna. For the water, glide a mixture of cobalt blue and white onto the canvas. Finally, dab white and yellow ocher down to indicate the crashing surf.

Mastering Soft, Unfocused Reflections

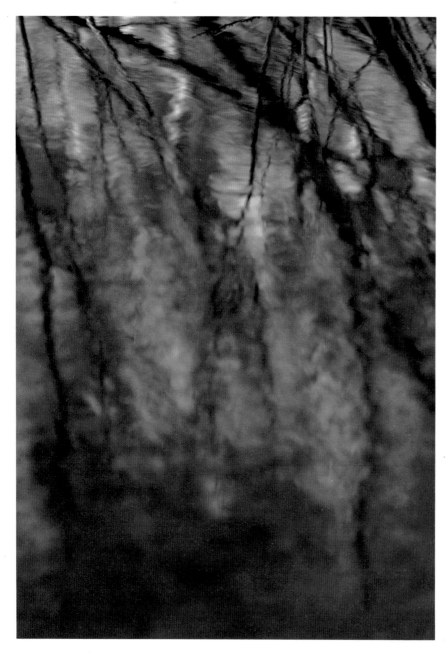

PROBLEM

There's very little to hang onto here. The shapes are soft and unfocused and the colors are indistinct.

SOLUTION

Work loosely, following what you see as closely as possible. Throughout, work wet-in-wet to maintain a soft, lyrical feel, but use vigorous brushwork to give a little energy to your painting.

STEP ONE

When you approach an abstract subject like this one, there's no need to execute a preliminary sketch. Instead, start painting right away. With thinned color and rapid, calligraphic strokes, start laying in color—Thalo green, permanent green light, cadmium yellow, burnt sienna, burnt umber, and cobalt blue.

Wind stirs across the surface of a pond, softening reflections of brilliant spring-green foliage.

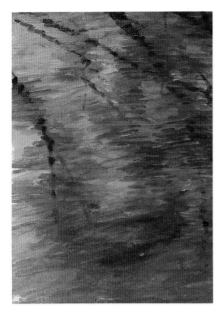

STEP TWO
Working wet-in-wet, and with
heavier color, continue to build up
the patterns formed by the reflec-
tions. As you work, brush one
color into the next, continually
softening edges to keep the im-
age unfocused. Adding a little
extra painting medium to your
color will make it easier to work
loosely.

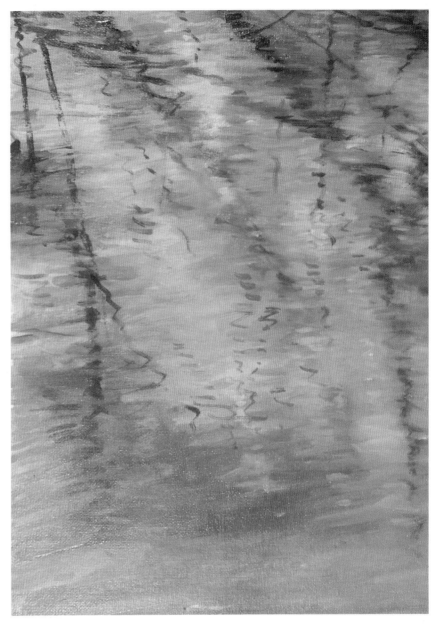

STEP THREE
Gradually introduce lighter shades
as you continue building up the
painting. Your strokes should
have a strong sense of direction,
following the motion of the water.
If the branches stand out too
sharply against the rest of the
colors, soften them by running
small touches of color back and
forth over them.

FINISHED PAINTING
Let the surface dry slightly. While you are waiting, analyze your painting. Are the branches too dark? Are some of the colors too bright? Are there sharp edges present? Now go back and make any adjustments that you think are necessary.

DETAIL
Seen up close, the many hues that make up the water become apparent. Yet, because they are laid in wet-in-wet, they blend together easily. More important, this basically soft subject is made stronger and more dramatic by energetic brushstrokes.

Working with Bold Color

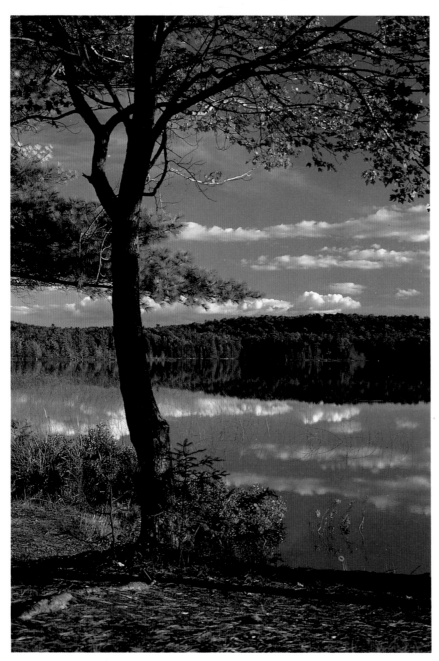

PROBLEM
This subject is straightforward. Only one problem is likely to occur: underemphasizing the bold color and the distinct shifts in value.

SOLUTION
Force yourself to use colors that are a little bolder than those you would customarily select. Then, as you paint, lay in the colors with strong, dramatic brushstrokes.

STEP ONE
Beginning with the tree, sketch the scene with vine charcoal. The tree down, fit in the rest of the shapes in the background. Now strengthen the drawing, making any necessary corrections, with thinned color. At this stage, working with a deep, dark hue will help you create a stronger, more dramatic painting.

In autumn, as leaves begin to turn brilliant shades of orange and red, a deep blue cloud-streaked sky is reflected in a placid lake.

STEP TWO
Working over the entire canvas, brush in the colors and values with thinned color. Let the white canvas represent any light areas. One major compositional change takes place in this step: The large green tree on the left is omitted because not enough of it is present to explain its form.

STEP THREE
Working with heavier color, move back and forth between the tree and the sky, painting the sky through the tree and the tree over the sky. Keep the contrast between the two strong. Alongside the strong reds that make up most of the foliage, introduce a few dabs of green and you'll achieve a more realistic look.

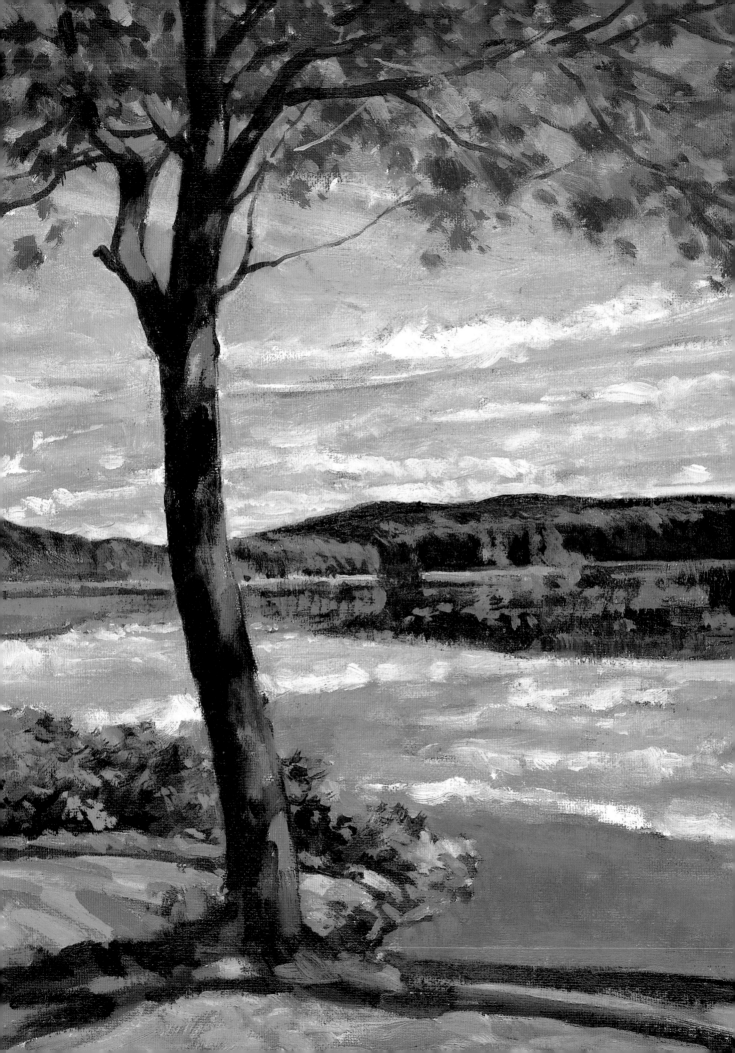

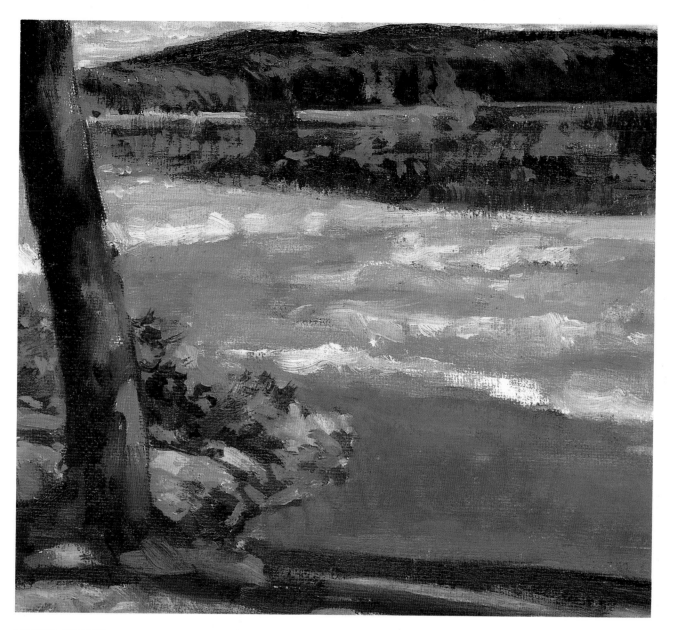

FINISHED PAINTING

Laying the pigment down with strong, sure strokes, finish the painting. First build up the leaves on the tree with cadmium red, cadmium orange, alizarin crimson, and Thalo green. The green foliage is rendered with Thalo green, permanent green light, and touches of yellow ocher. For the water, use cerulean blue, Thalo blue, white, and a tiny bit of black. The ground is laid in with bold strokes of burnt sienna, yellow ocher, and permanent green light.

DETAIL

Painted with cerulean blue, Thalo blue, white, and black, the water is actually darker than the sky it reflects. By making the water darker than it actually is, you can direct attention to it and to the tree that dominates the foreground.

Rendering Thin Ice

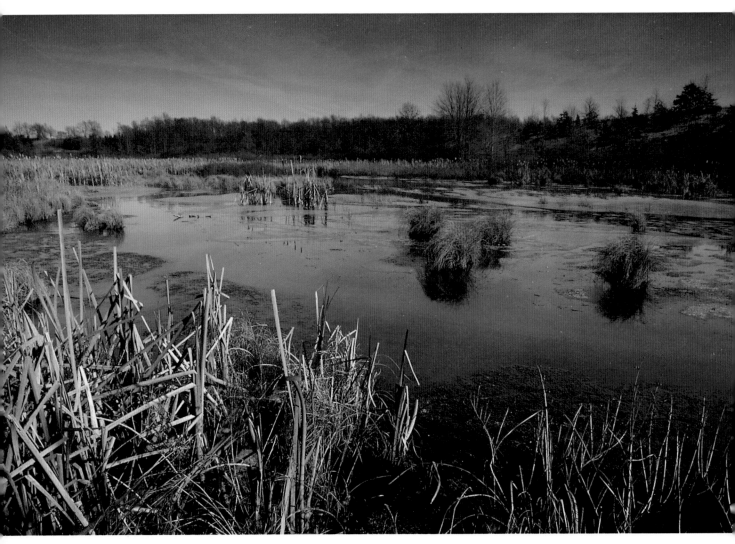

PROBLEM
Thin ice floating on water is never easy to depict. In a complex, busy composition like this one, it becomes even more difficult.

SOLUTION
At first, concentrate on the water and the sky, ignoring the grasses in the foreground and the land that lies in the distance. Try to capture all the patterns in the sky and all the motion in the water.

☐ Sketch the scene with charcoal, paying special attention to the soft clouds and the surface of the water. Now reinforce your drawing with thinned color.

Working all over the canvas with thinned pigment, start to build up your colors and values. Start with the sky, then turn to the water, painting it all the way down to the bottom of the canvas. You can add the grasses later.

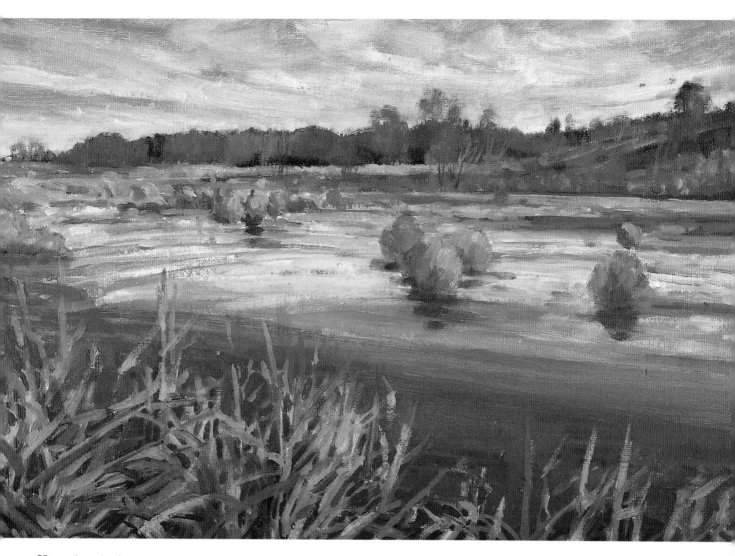

Here the sky is made up of cobalt and cerulean blues, plus white and black. The water is rendered with cobalt blue, cadmium red, and white.

With heavier paint, establish the dark trees in the distance using Mars violet, burnt sienna, and cobalt blue. Now build up the sky; as you paint, let your paint ease down into the trees, softening their silhouettes.

For the water, use long sweeping brushstrokes to suggest its movement. Try to capture as much variety in color as possible, and make the water in the immediate foreground darkest.

At the very end, add the foreground grasses, painting over the water. In some places, you may find it necessary to paint back and forth between water and grass.

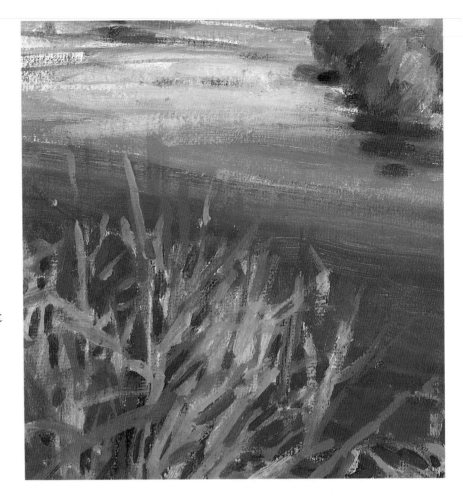

DETAIL

The entire water surface is first laid in using thinned cobalt blue, cadmium red, and white. The water in the foreground is darkest and is painted right down to the bottom edge of the canvas. Long sweeping brushstrokes are used to suggest the movement of the ice floes on the water's surface. The cleanest whites are applied last. In the meantime, the dark blue at the bottom is drying and the tall grasses are now painted over the blue.

ASSIGNMENT

Search your neighborhood for an interesting lakeshore, pond, or stream—or even a large pool of water—then study it for several weeks. First sketch it carefully, capturing every small detail. Try working on a large sheet of paper, then smaller surfaces. Next, render it in oil. Paint it at dawn, midday, and dusk, under different weather conditions, and from different angles and at different distances.

What can be gained from this experimentation? The freedom to concentrate on the issues that most concern you. In your preliminary sketches, you'll work through basic compositional problems and solve any difficulties with color and value, leaving you free to examine the way the water moves, how light plays upon it, and how the scene changes with time.

Exaggerating Colors and Contrasts

PROBLEM

This scene has no real focal point. To make matters still more difficult, it's made up of just a few subdued colors.

SOLUTION

Make the colors warmer and brighter than they actually are, and exaggerate the contrast between the foreground and the background.

☐ When a scene is as simple as this one, there's no need for a complicated charcoal sketch. If you're feeling very confident, sketch the composition directly with thinned color. Or use charcoal, instead, to get down the basic shapes, then go over the lines of your drawing with thinned color.

Use thinned color to block out the major areas of the composition. Working all over the canvas, lay it in, trying to capture the approximate color and value of every area. For the time being, let the white of the canvas represent the stream.

Working back over the thin underpainting, develop the color and texture of the meadow. Don't use any white! Set up a palette of burnt sienna, light red, cadmium orange, and yellow ocher. You'll also need a little Thalo green. As you put down the pigment, look for the patterns that lie in the grasses. Use short, vertical strokes that mimic the feel of the meadow, and lay in the color all the way to the top of the canvas. Now let it dry, then add the trees.

When all of the other elements have been developed, turn to the water. Here it's made up of white and yellow ocher, with touches of Thalo green. At the very end, add the patches of grass that grow out of the water.

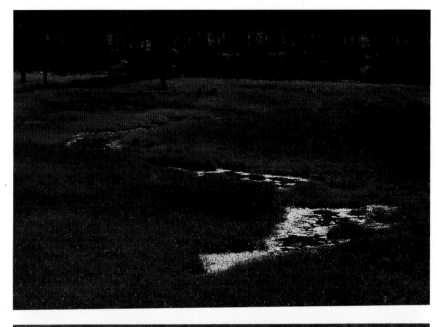

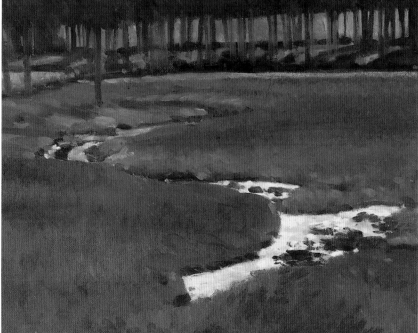

In a western meadow, late-afternoon sunlight glistens on the water of a slow-moving stream.

Capturing the Beauty of a Sunset

PROBLEM

Nature's most dramatic moments can be very difficult to capture in paint. Here the fading sun silhouettes the hills and the trees, making them stand in sharp relief against the sky and the water.

SOLUTION

To make your painting more interesting, break up the surface with short strokes of broken color. At the same time, add dashes of purple and pink to the orange sky.

☐ No drawing is necessary here—the subject is quite simple. Begin by drawing directly with a small bristle brush that's been dipped into thinned color. At this stage, all you have to do is place the land mass and its reflection on the canvas.

Now working with Thalo blue and alizarin crimson, lay in the tree-studded land. From the beginning, work with opaque pigment. Lay the color down with short, rapid strokes, and don't let your color become too flat. In some areas, let the Thalo blue shine out; in others, let alizarin crimson dominate.

Next, using the same hues, lay in the reflections that lie in the water.

Now turn to the sky and the water. At the top of the canvas, work with cadmium orange. As you approach the horizon, add cadmium red. Near the land, streak alizarin crimson across the sky. To render the water, work with the same colors.

Let the surface dry, then turn to the leafy branches that fill the upper left corner. Using charcoal, sketch them, then paint them with a mixture of Thalo blue and alizarin crimson, mixed with a dab of painting medium to keep the pigment flexible. As a final step, add the tall scraggly tree that shoots above the land on the left.

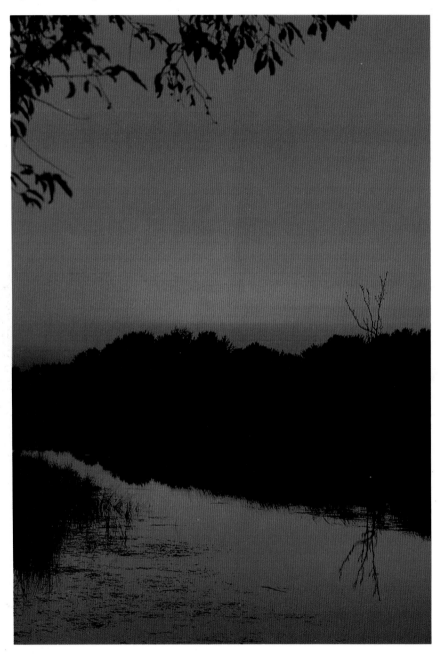

As the sun slowly sets, glorious color floods the sky, the land, and the water.

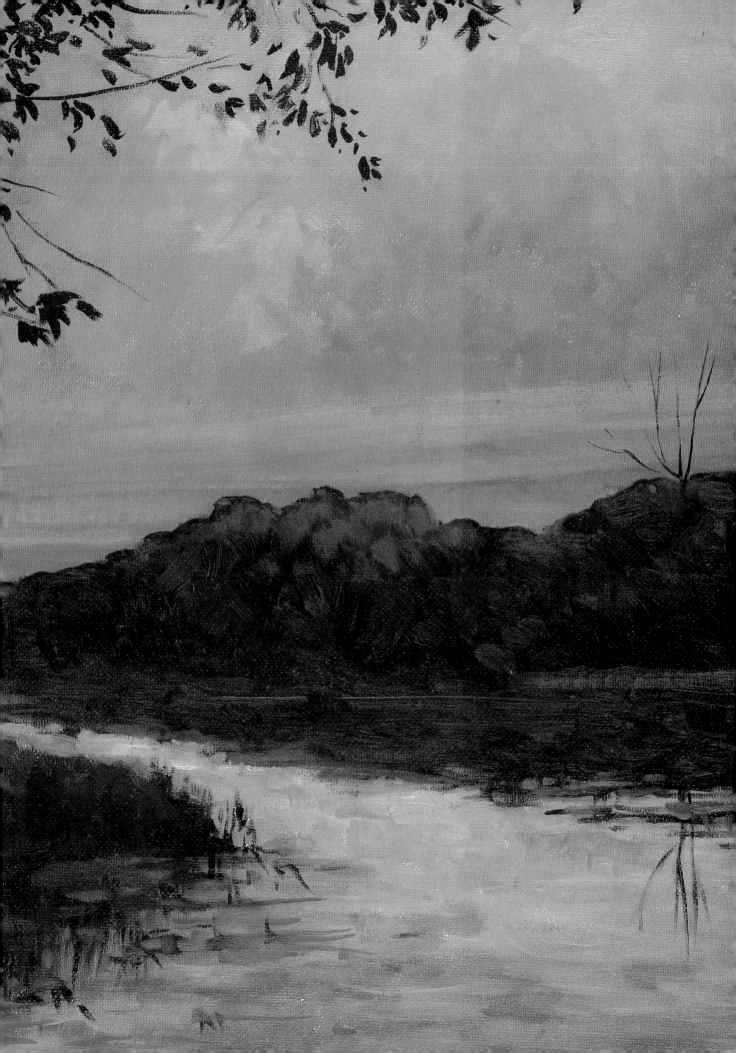

Painting Late-afternoon Light

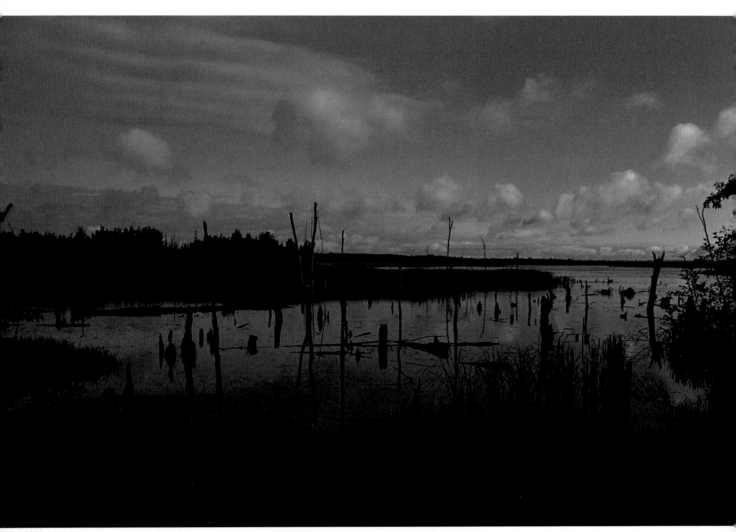

PROBLEM

Two elements give this composition power—the sky and the water. Both have to be rendered with care to make your painting work.

SOLUTION

Tie the sky and water together by using related hues. More important, note what makes the two areas different—the water is darker than the sky and it's filled with shadows.

A marsh sweeps back toward the horizon,
its water softly reflecting the cloud-filled sky.

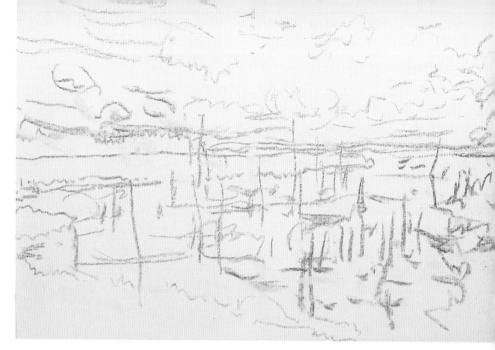

STEP ONE

Think of your preliminary drawing as a form of visual shorthand. In it you can capture what matters to you, be it the movement of the clouds, the physical power of the land, or the reflections that lie in the water. Work rapidly, getting down everything important in soft vine charcoal.

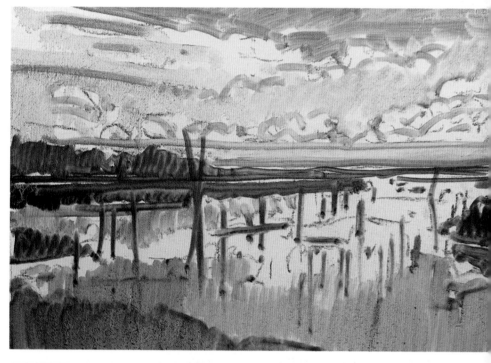

STEP TWO

Working with cobalt and Thalo blues that have been thinned with mineral spirits or turp, establish the value scheme. Think of this step as a color sketch. In it, you can capture not only values, but also the movement that will run through the finished work. For the darkest passages, mix a little black into your blues.

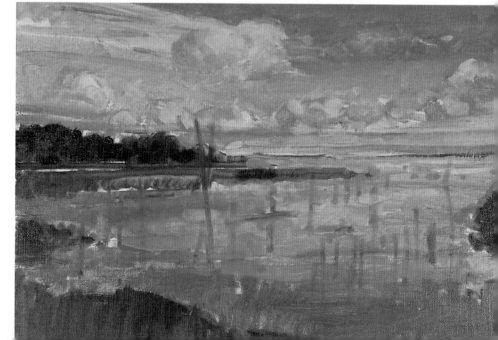

STEP THREE

Working now with thicker pigment, build up your composition. Start with the darks that dominate the water in the foreground and the land, then turn to the sky. As you render the sky, work around the clouds. When you start to paint the clouds, remember that they have both dark and light sides—they're not pure white. Here alizarin crimson warms both the sky and the water.

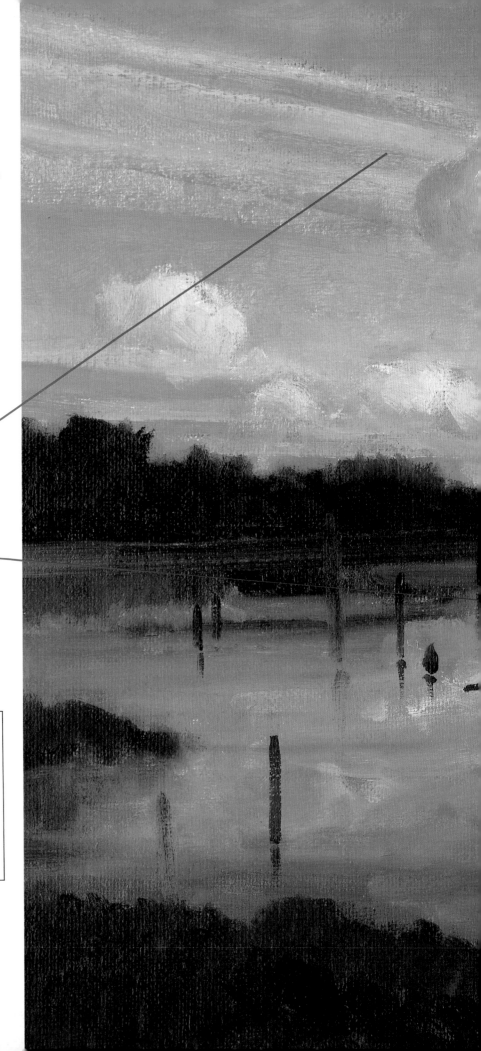

FINISHED PAINTING
Complete the sky. Touches of yellow ocher enliven the clouds; strong brushstrokes make them sweep across the sky. Cerulean blue warms the water, and strokes of blue plus alizarin crimson and white are laid down in the foreground.

As a final step, the darkest values are added. For the land mass in the distance, scrub a mixture of Thalo blue, black, and burnt umber onto the canvas. Use denser pigment in the immediate foreground, and a drybrush technique to render the trunks that break through the water.

In the final stages of the painting, while the pigment is still pliable, a stiff brush is pulled across the sky to evoke the motion of the clouds.

The tree trunks that rise above the water are rendered with a drybrush technique. They are still dark, and add drama to the picture, but not so emphatic that they steal attention from the subject of the painting—the dramatic light that makes the water and the sky exciting.

ASSIGNMENT
As this lesson shows, a scene set in late-afternoon light needn't center on the falling sun. Try this: Look away from the sunset, and study the effect the failing light has on the rest of the land. You'll find a world filled with subdued drama, rich with contrast between darks and lights.

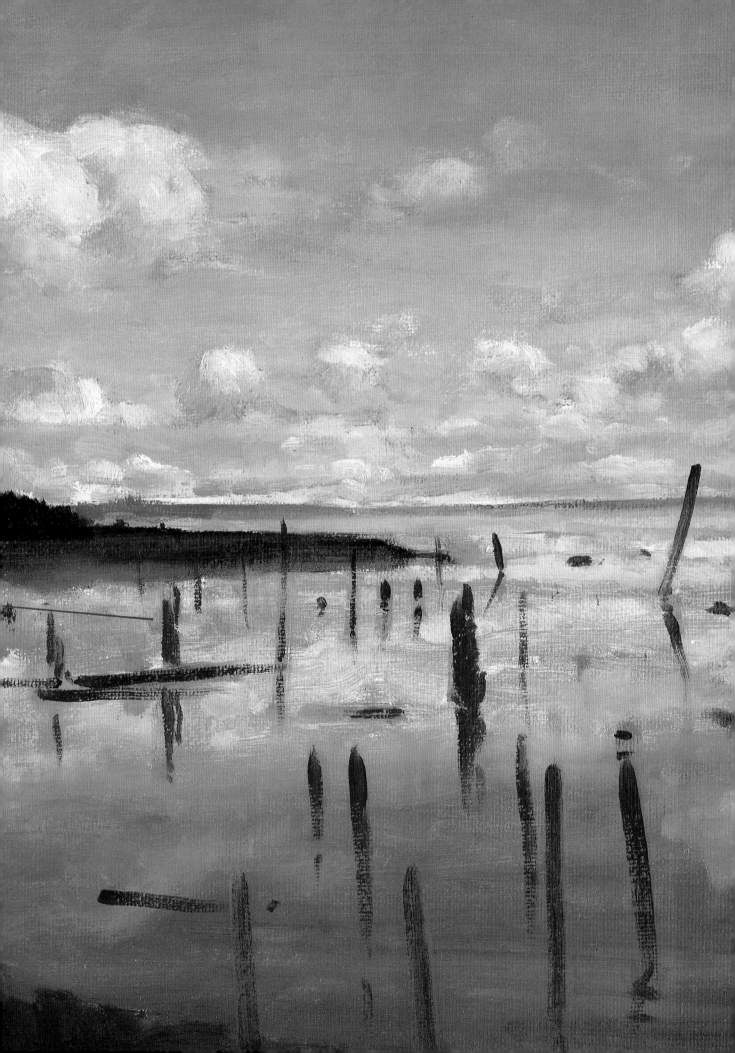

Breaking Up a Pattern of Dark, Dull Green

PROBLEM

What makes this scene special is the bright slash of blue that the water cuts against the green foliage. But the greens have to be tamed if the water is going to stand out against them.

SOLUTION

Look for nuance—the greens in the foreground are slightly warmer than those in the background, and their shapes are rounder, too. Make the greens as varied as possible, and exaggerate the differences in every other hue.

☐ Make a simple drawing to place the patterns of the foliage and water. Pay special attention to the foliage; it will be difficult to paint because it has no real form, but blends, instead, into an overall pattern. Now go over your drawing with thinned color, organizing the dark and light shapes—and emphasizing their differences—to add interest to these areas.

Start to work with thicker pig-

A ribbon of brilliant blue water runs through a land filled with silver-green shrubs and trees.

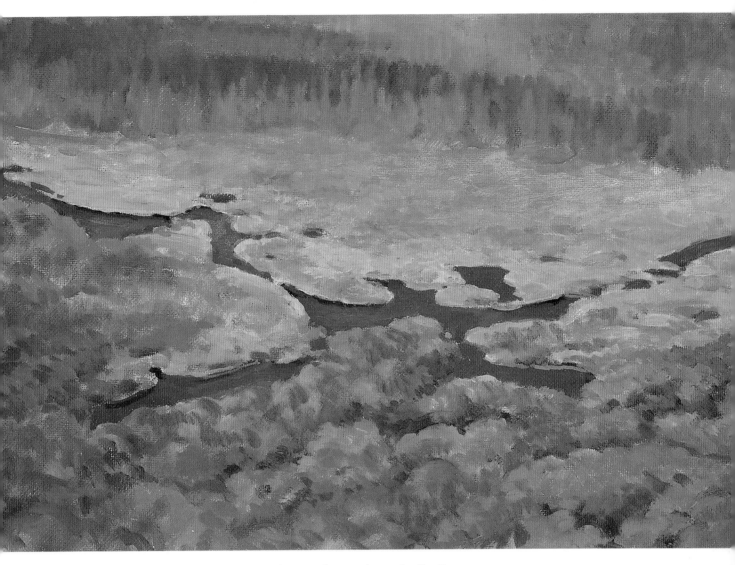

ment. Begin with the foreground, developing the texture of the trees and bushes that lie there. Use short, rounded strokes and warmer hues. Here permanent green light, Thalo green, and Thalo yellow-green, plus white come into play.

Turn to the distant trees. Work with the same greens, but add touches of cobalt blue and still more white. Vertical brushstrokes laid in smoothly will pull the background away from the livelier foreground.

Finally, lay in the water. Make it stand out: It should be carefully drawn before you put brush to canvas. A clear, vibrant tone of cobalt blue is perfect. Once it's down, add a bit of Thalo blue to your palette, then go back and emphasize the shadows that lie right along the banks.

Painting Soft, Blurred Reflections

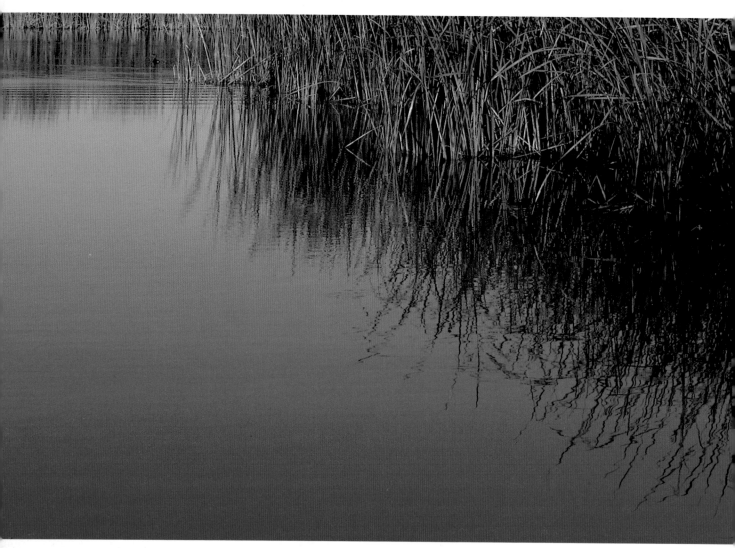

PROBLEM
What makes this scene special at first seems to be the juxtaposition of the greenery and the cool blue water. Look closer. The soft reflections are actually the focus of the composition.

SOLUTION
Paint the grasses with crisp, clean strokes and the reflections wet-in-wet. All the while, work back and forth between the water and the blurred reflections, and you'll make the two areas work well together.

Cattails arch proudly toward the sky, then are reflected in the clear blue water of a pond.

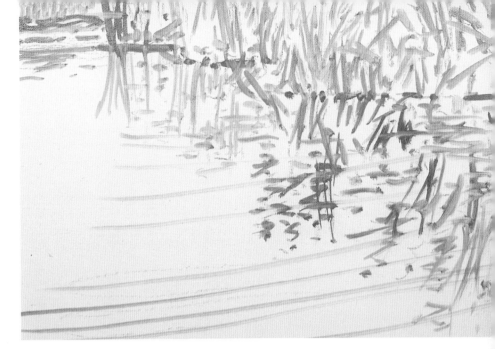

STEP ONE
There's no need to depict every blade of grass; in fact, it would be impossible to do so. So start working immediately with a brush and thinned pigment, instead of executing a preliminary drawing. In your color sketch don't try to capture every detail; just try to get the feeling of the massed grasses and their reflections, and the colors they are made up of. With a few sweeping strokes, suggest the movement of the water.

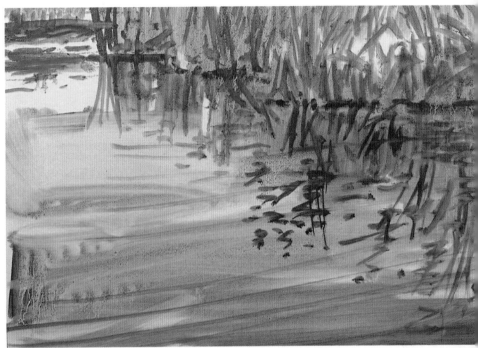

STEP TWO
With thinned color, go back over the initial oil sketch. At this stage, try to establish the color mood of the painting and its value scheme. Work over the entire canvas with pigment that has been thinned enough to let the oil sketch shine through.

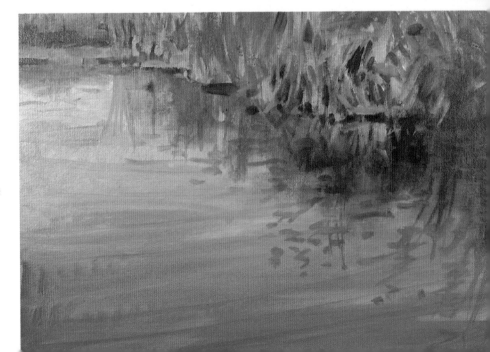

STEP THREE
With thicker opaque pigment mixed with plenty of painting medium, start to paint the water and the reflections. Work wet-in-wet, and don't pay too much attention to detail at this point. Build up the grasses along the bank by laying them in stroke after stroke, working back and forth between the grasses and the darks that lie between them.

FINISHED PAINTING

The stage is now set for the final steps. Working with a small bristle brush, pull out the individual blades of grass. To strengthen their edges, try using a rigger brush. You'll find it especially helpful when it comes time to lay in the long, fluid lines that make up the reflections. As a finishing touch, drag blue pigment over the water to soften it and make it more believable.

The crisp, clean grasses are established with overlapping strokes laid down with a fine brush. Their reflections are worked more loosely, wet-in-wet.

At the very end, the water is subdued with a thin layer of color. Through this final layer of color, you can see the more dramatic brushstrokes that were first put down, but they don't pull attention away from the focus of the painting—the rich green grasses.

ASSIGNMENT

Landscape artists tend to feel that each painting must be made up of land and sky, and sometimes water. This just isn't so. Look at the scene covered in this lesson. The sky is there, of course, reflected in the color of the water. But much more important is the surface of the water, rich with reflections.

Try closing in on subjects, searching for more intimate views of the land. Water is so rich and varied that it provides a logical starting point. Try sketching—then painting—a number of small scenes that feature just the water and land. In the water, try to capture the mood of the absent sky.

Index

Editorial concept by Mary Suffudy
Edited by Elizabeth Leonard
Designed by Bob Fillie
Graphic production by Hector Campbell
Text set in 11-point Century Old Style